He is invisible in such a world
Written and photographed by James Spicer

GALLERY HIDDEN PRESS

Chicago

Copyright ©2007 James Spicer

All rights reserved which includes the right to reproduce this book or portions thereof in any form whatsoever. For contact information visit www.galleryhidden.com.

ISBN: 978-0-6151-8010-6

Gallery Hidden Press®
Chicago

www.galleryhidden.com

I have unfathomable dreams.

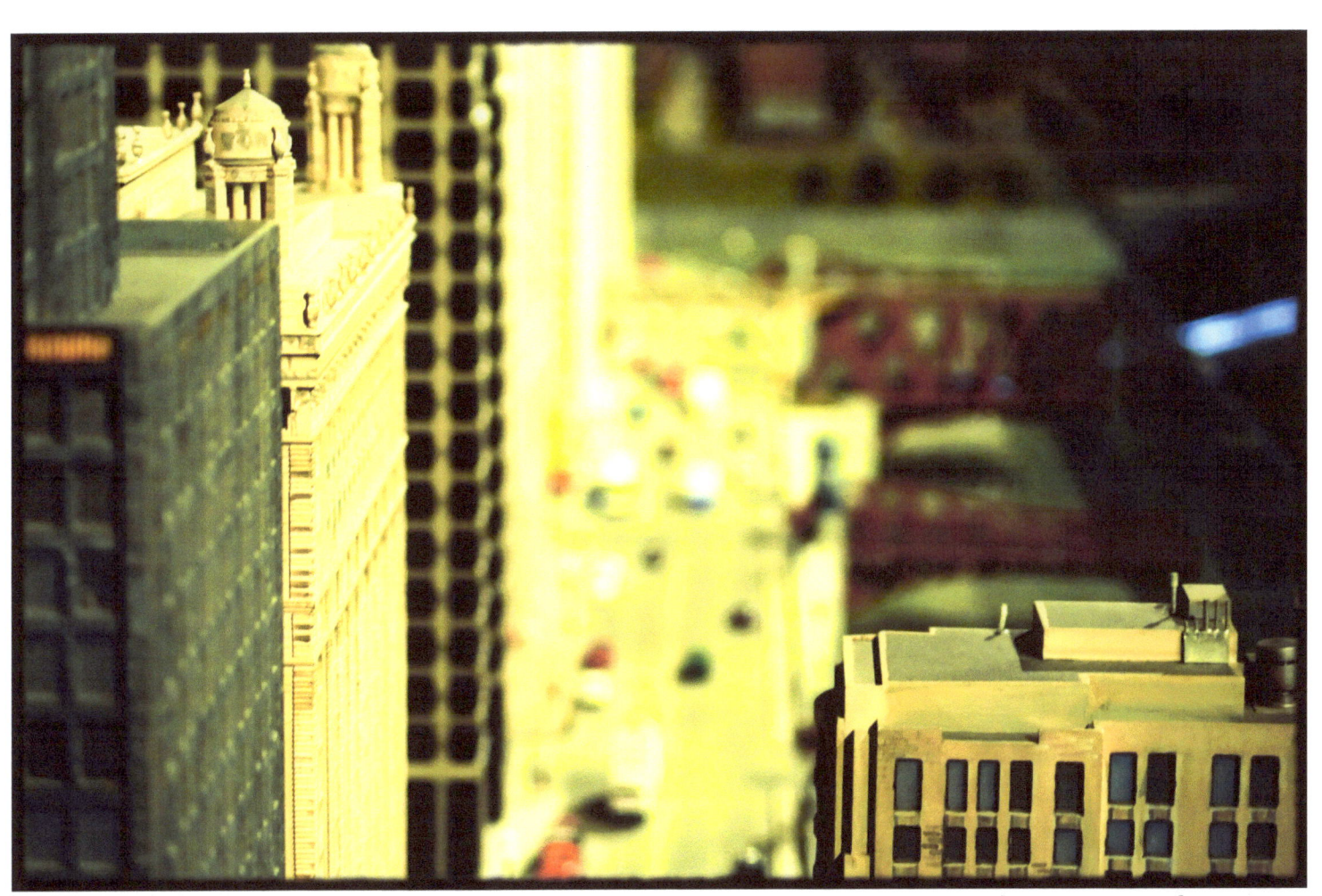

Look up and see.

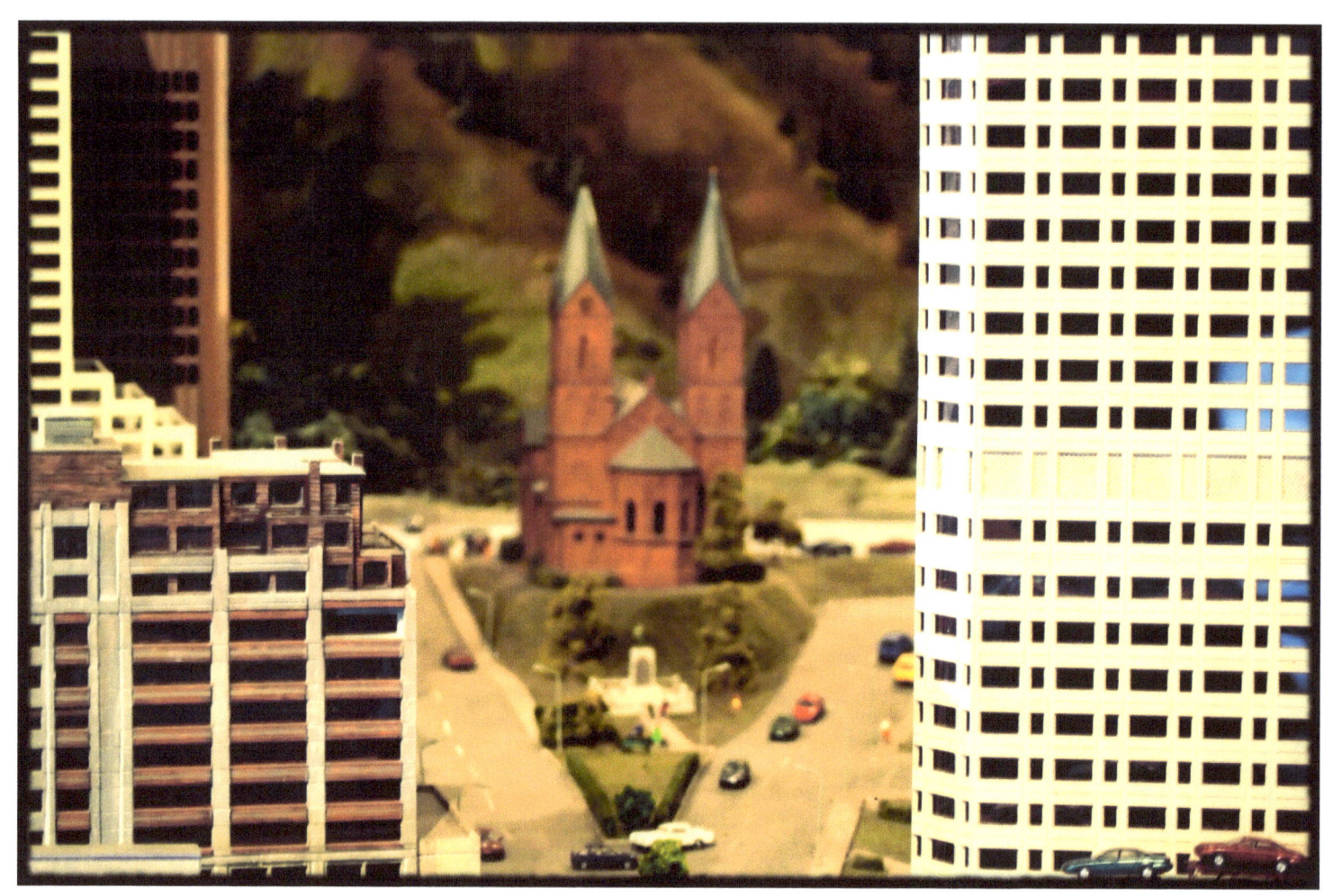

A misunderstanding.

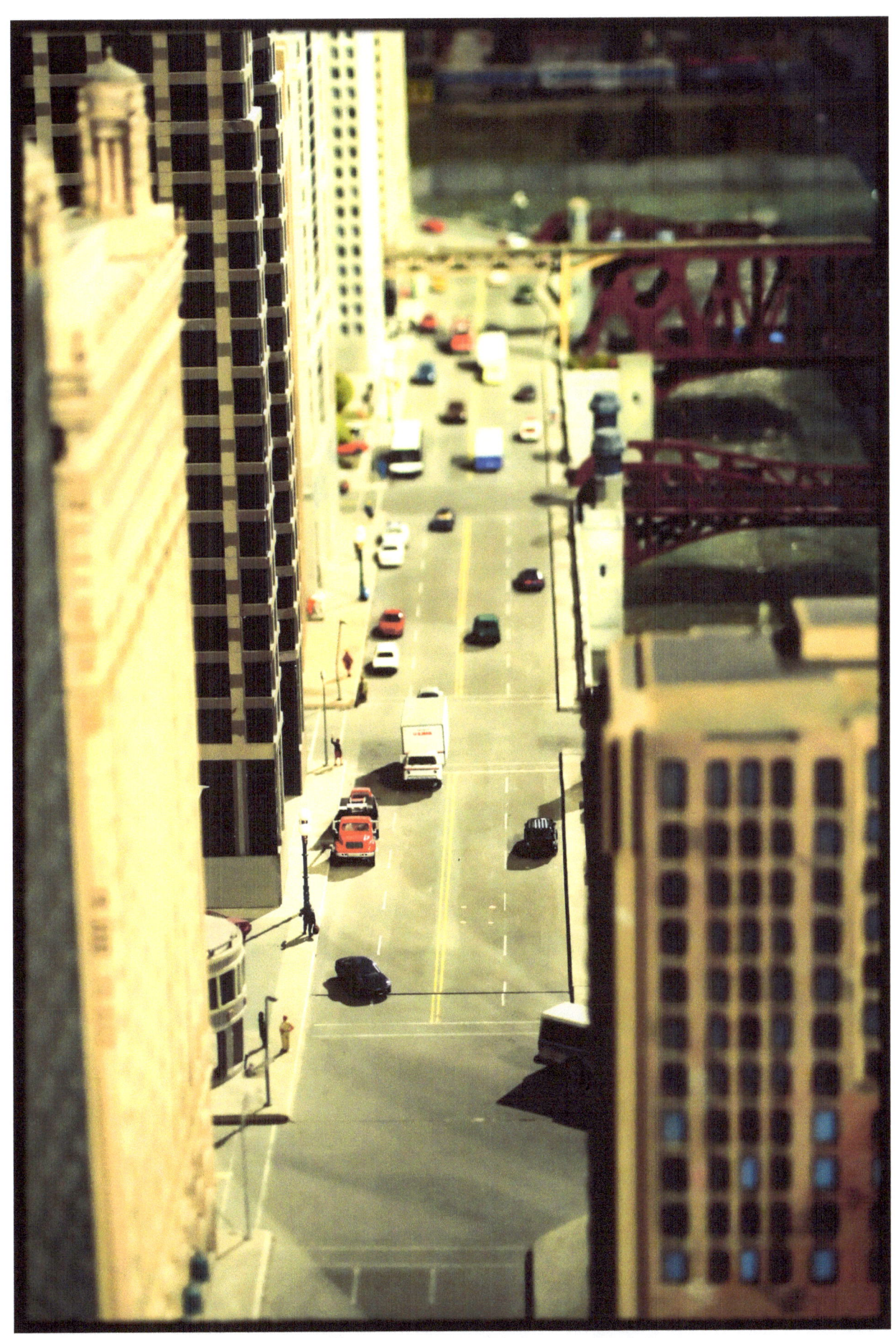
A sudden shift from horizontal to vertical perception.

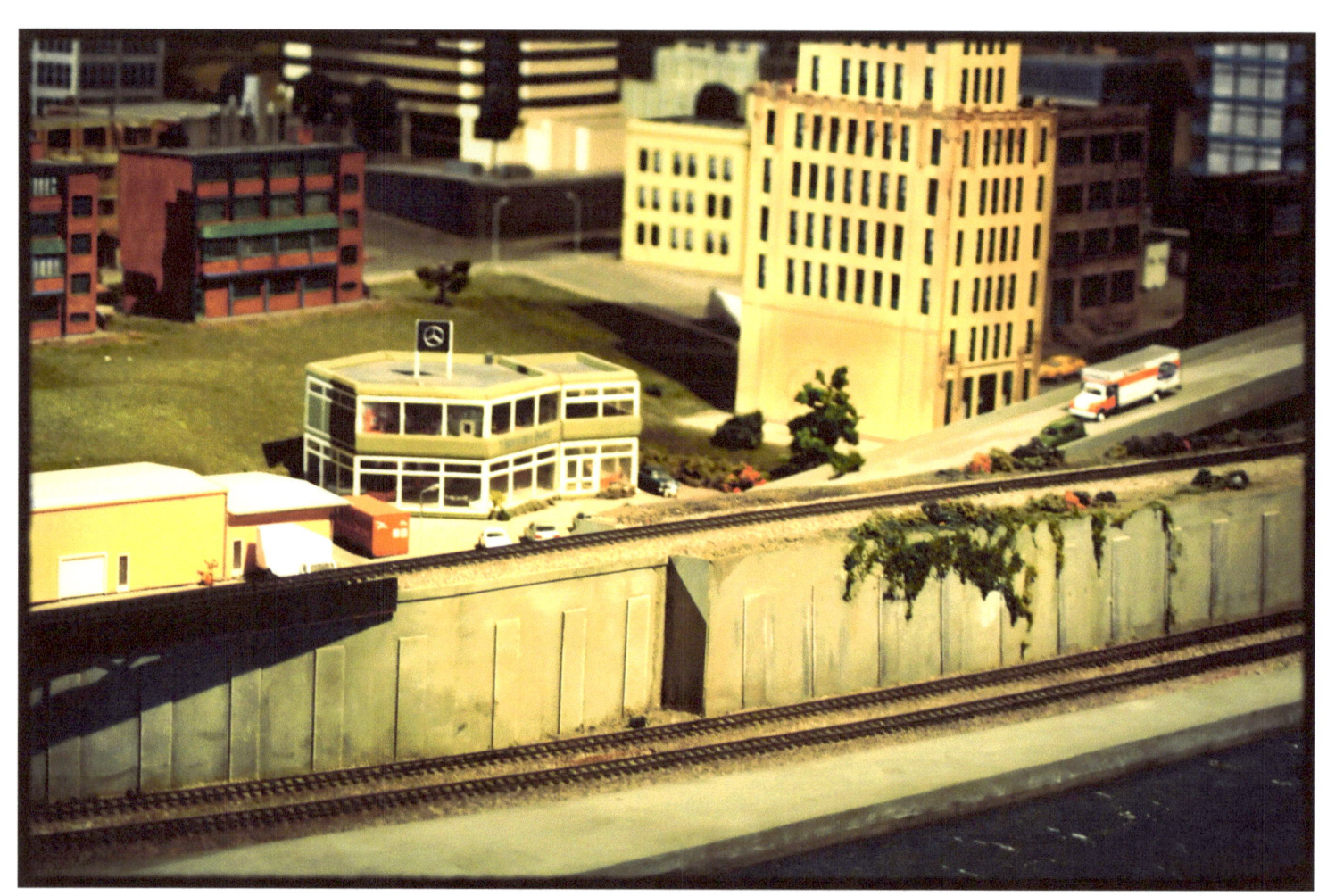

This is because you think you live in space.

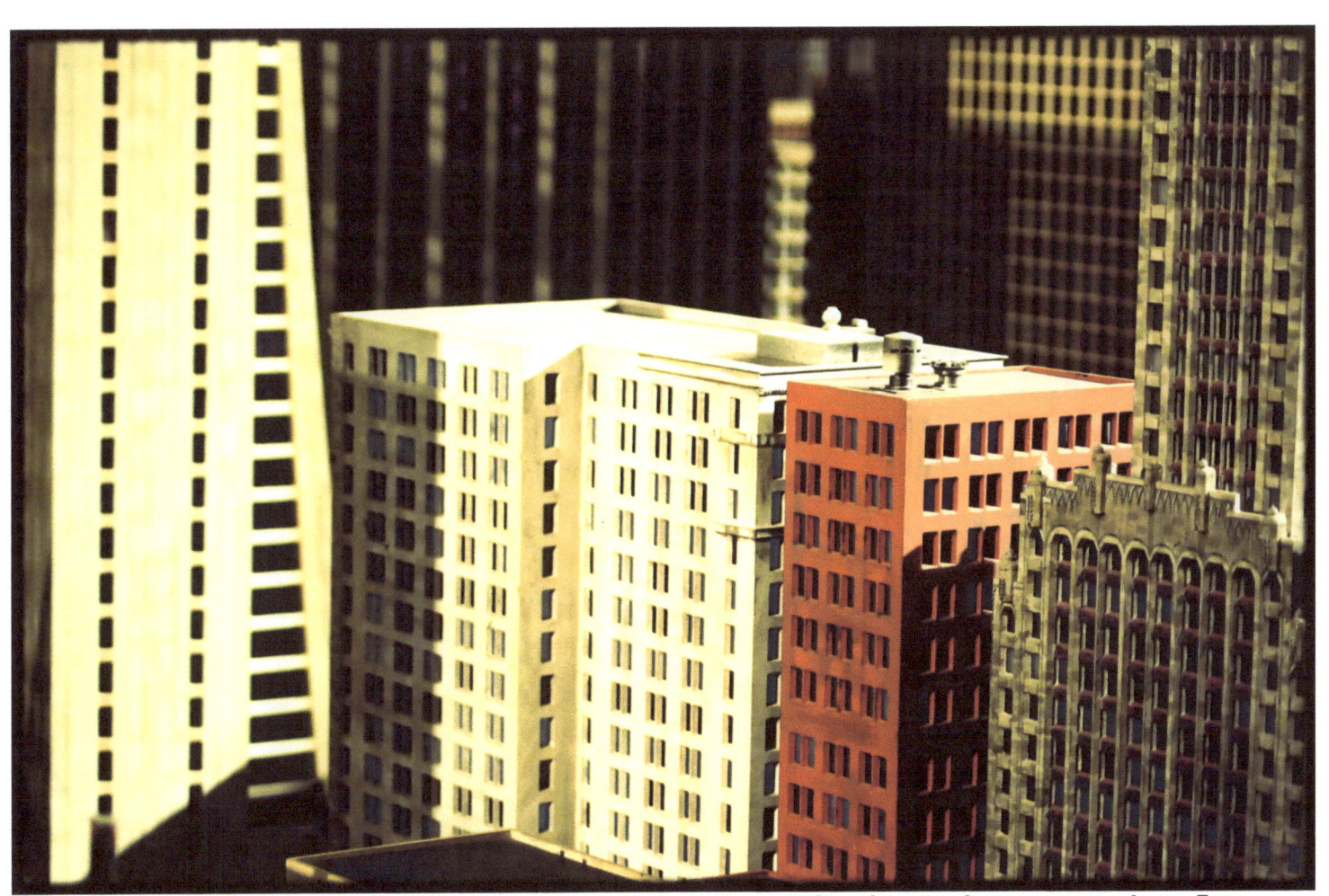

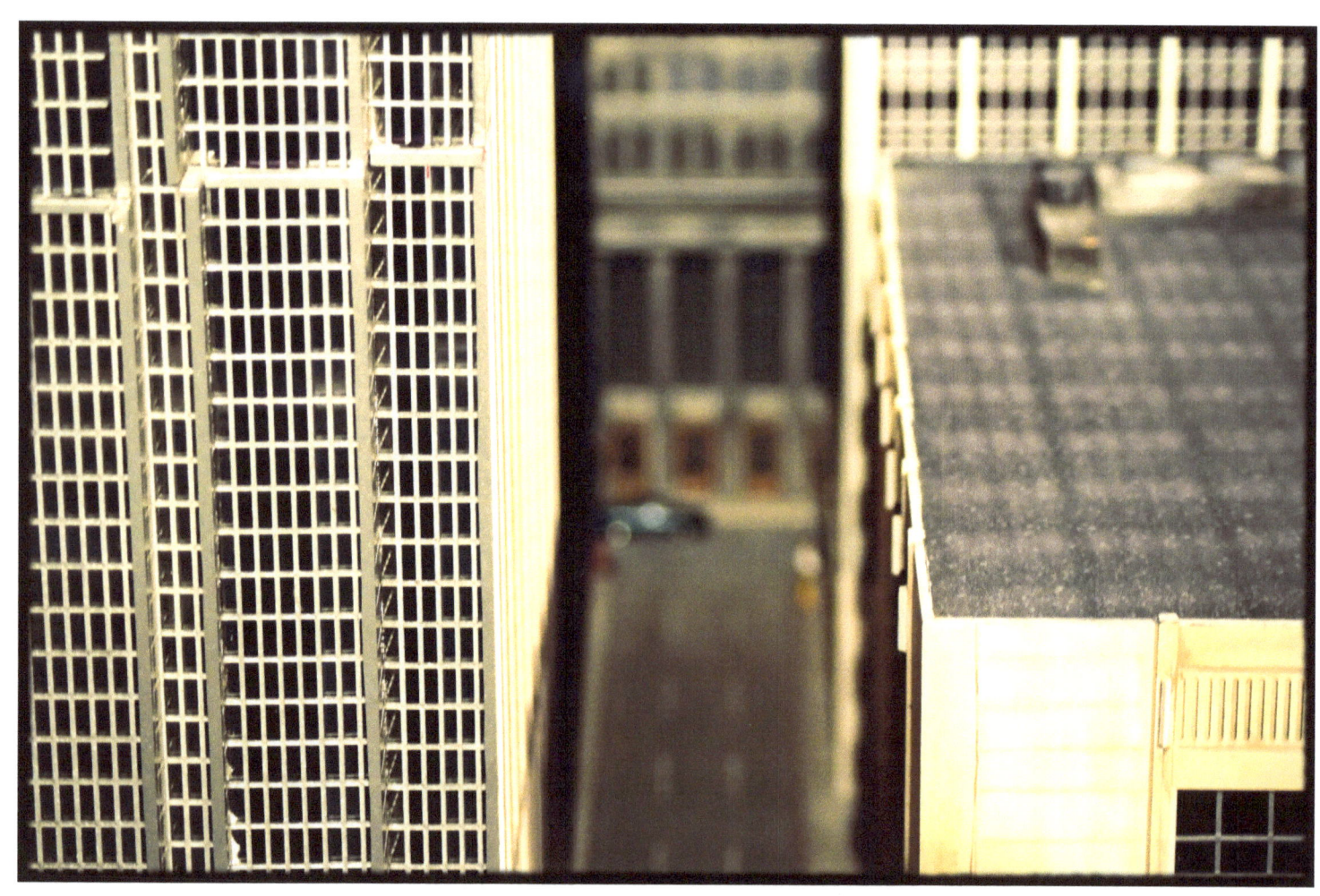

Up and down are meaningless.

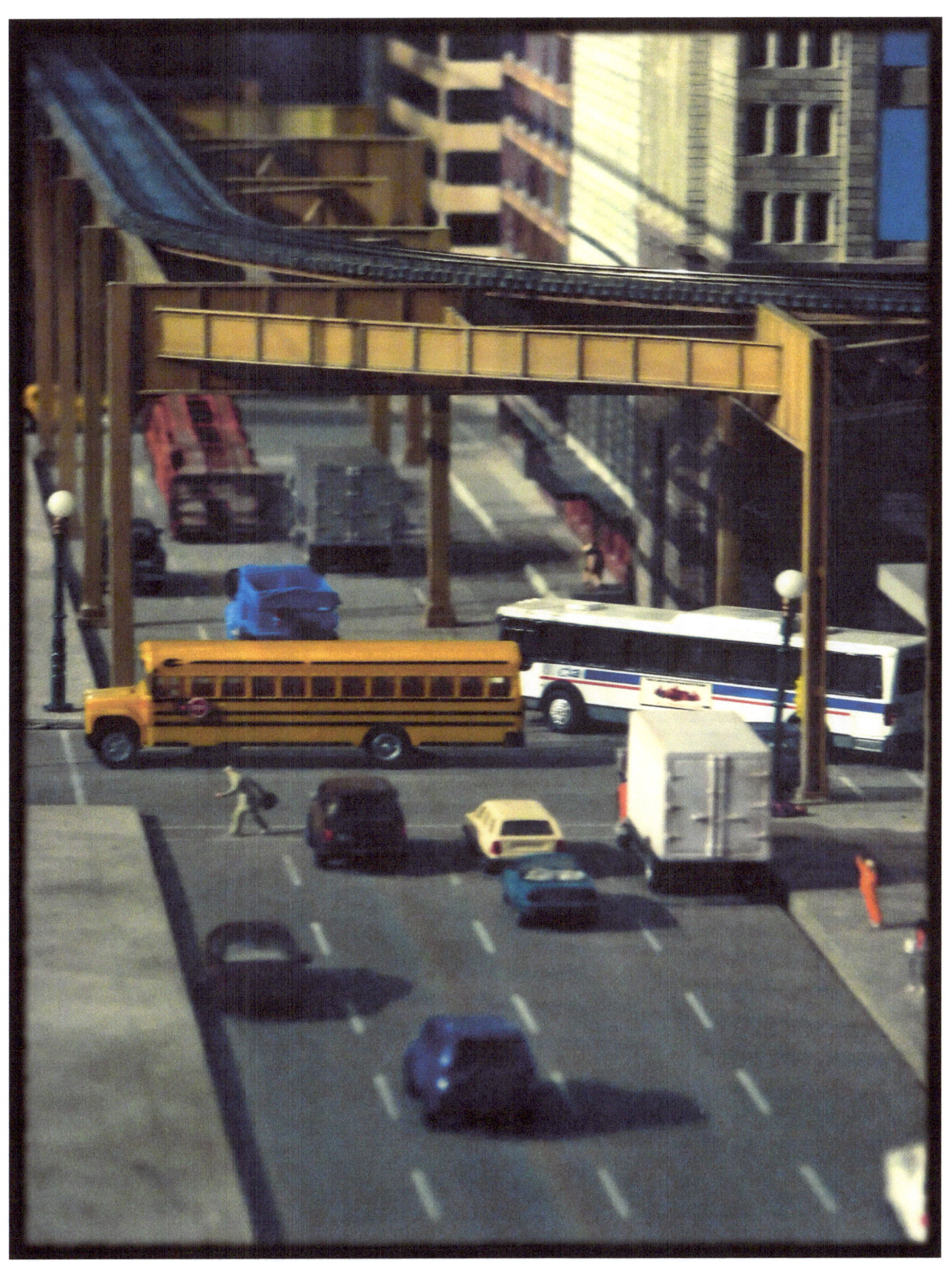
They work all the time and in all dimensions of time.

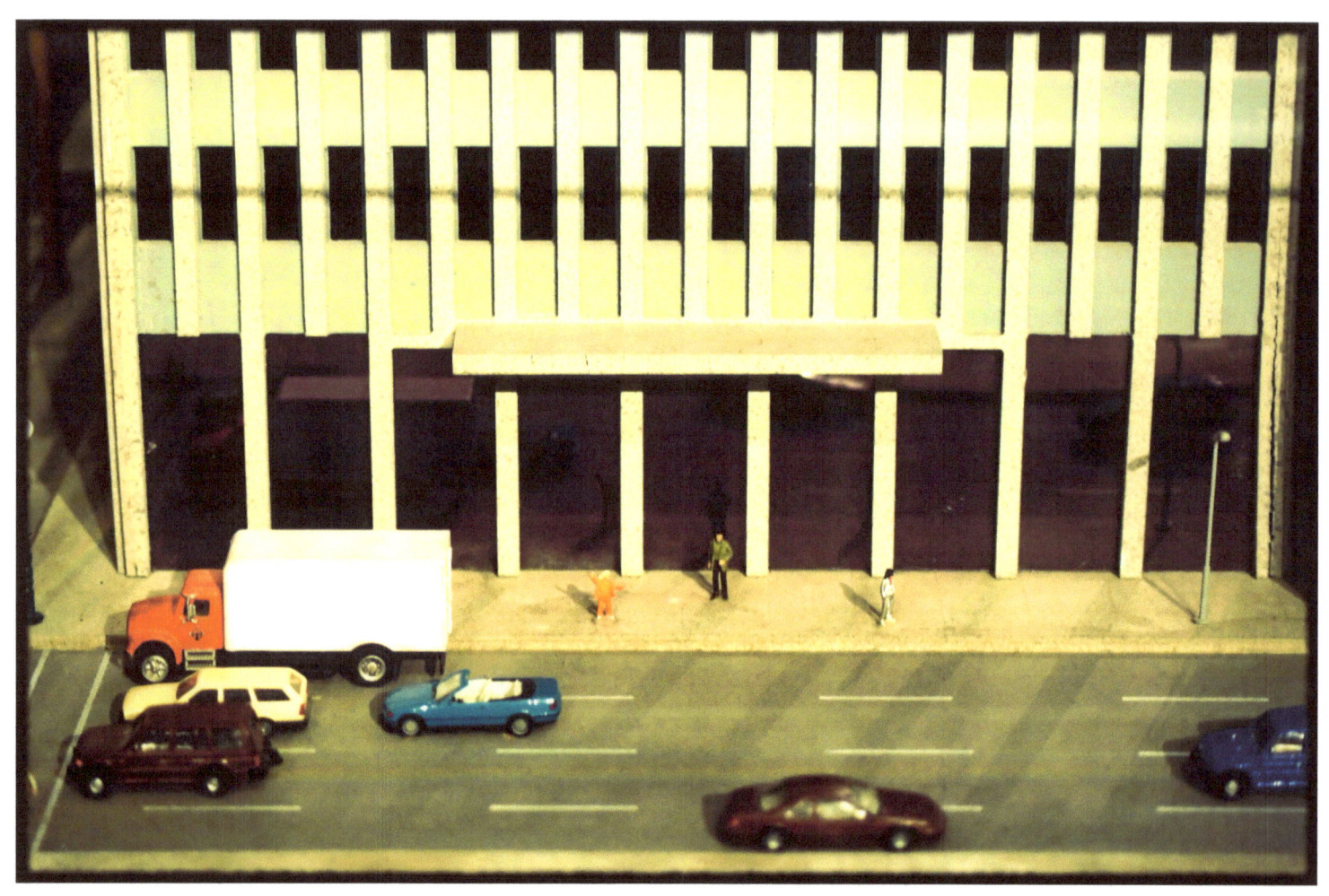
Those who have not yet changed their minds.

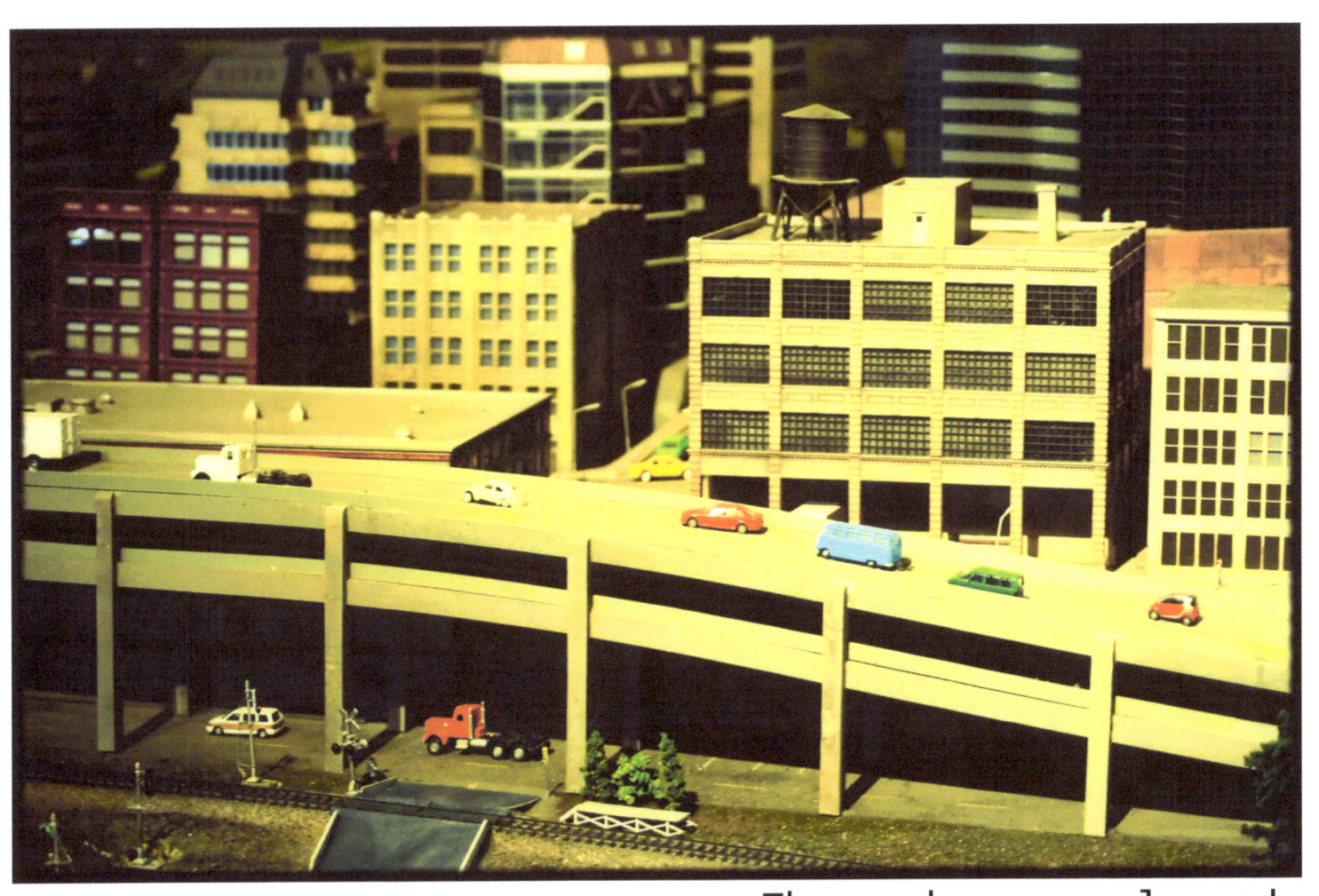

Those who are released.

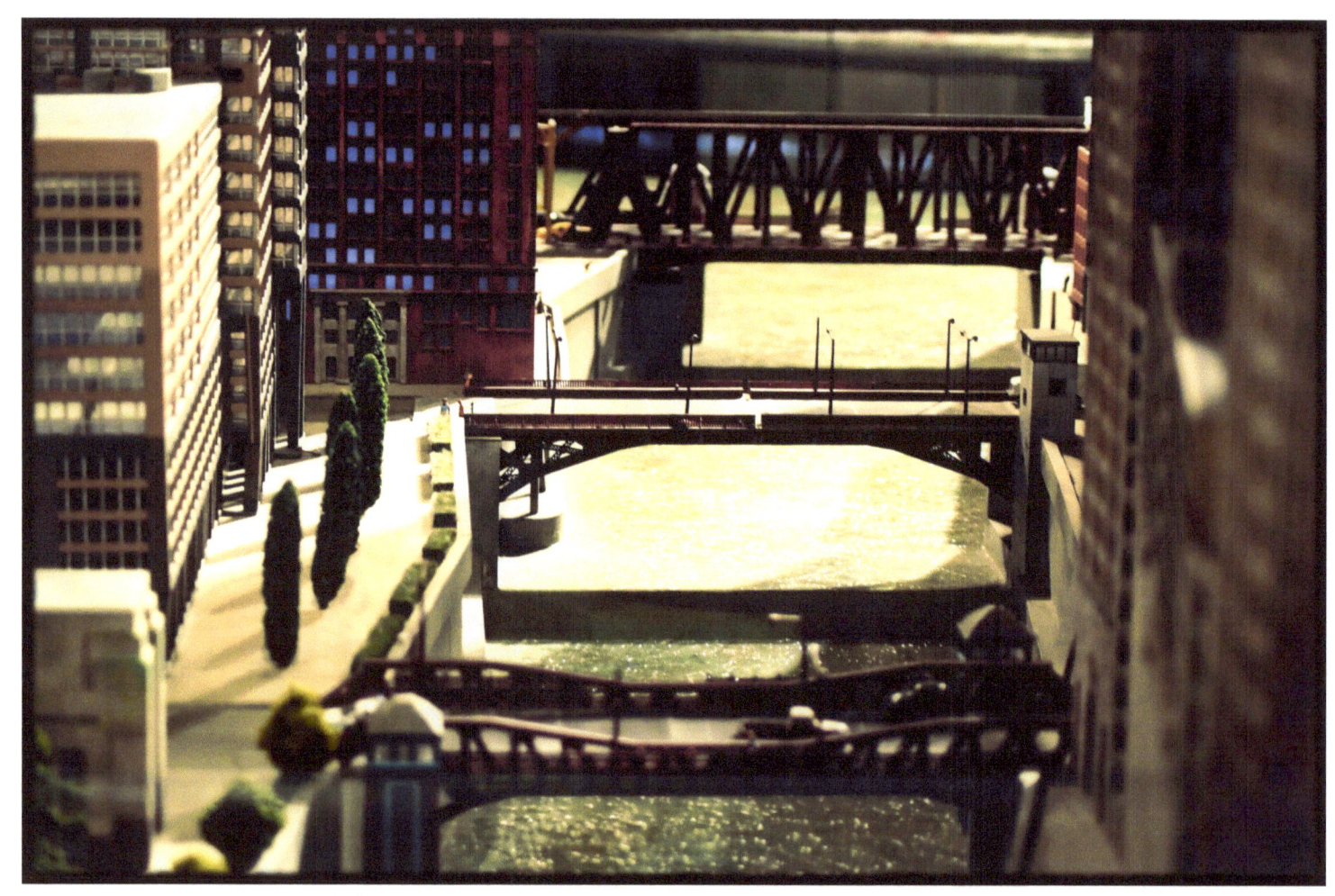
Implications that will be amplified later on.

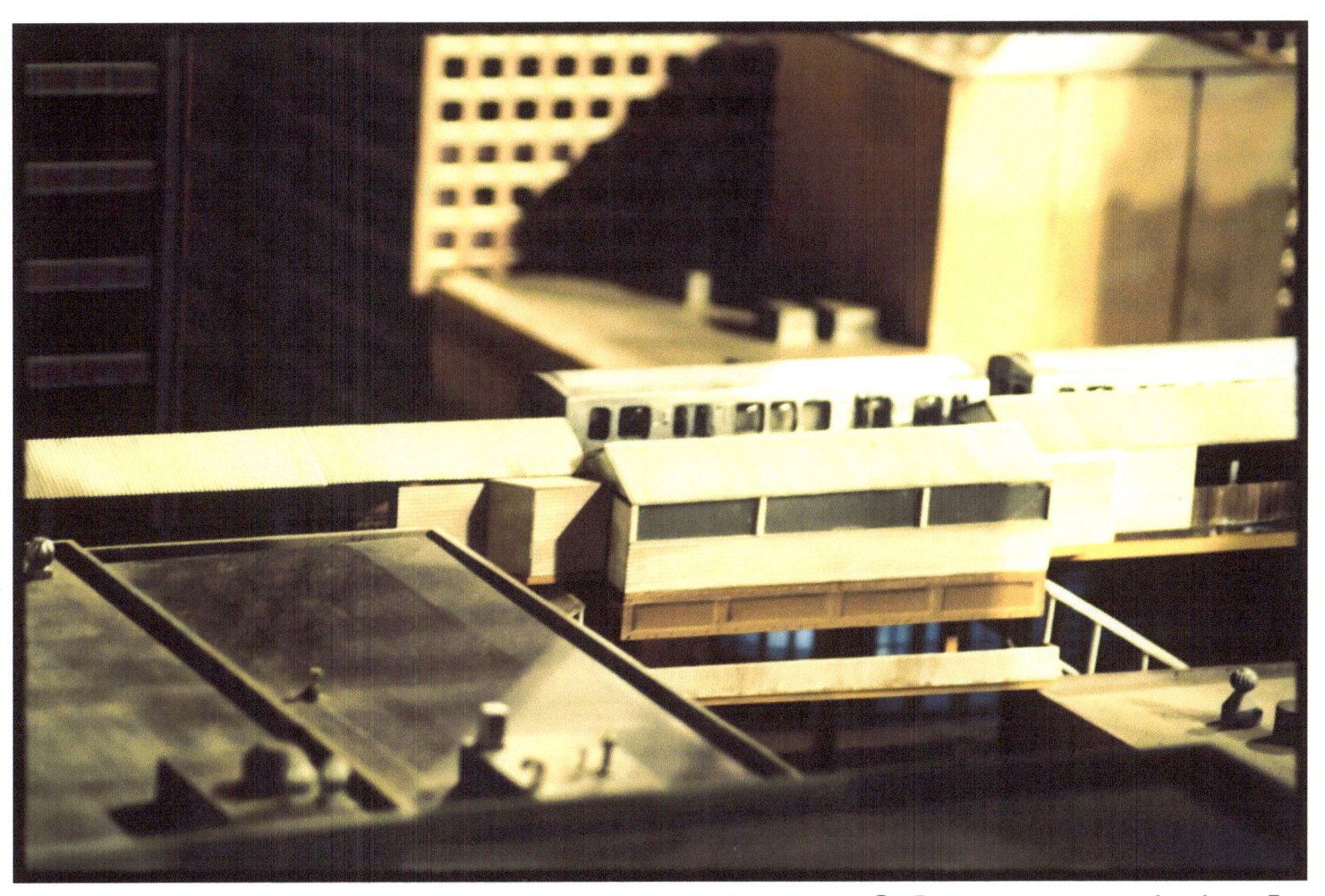

All expressions of love are minimal.

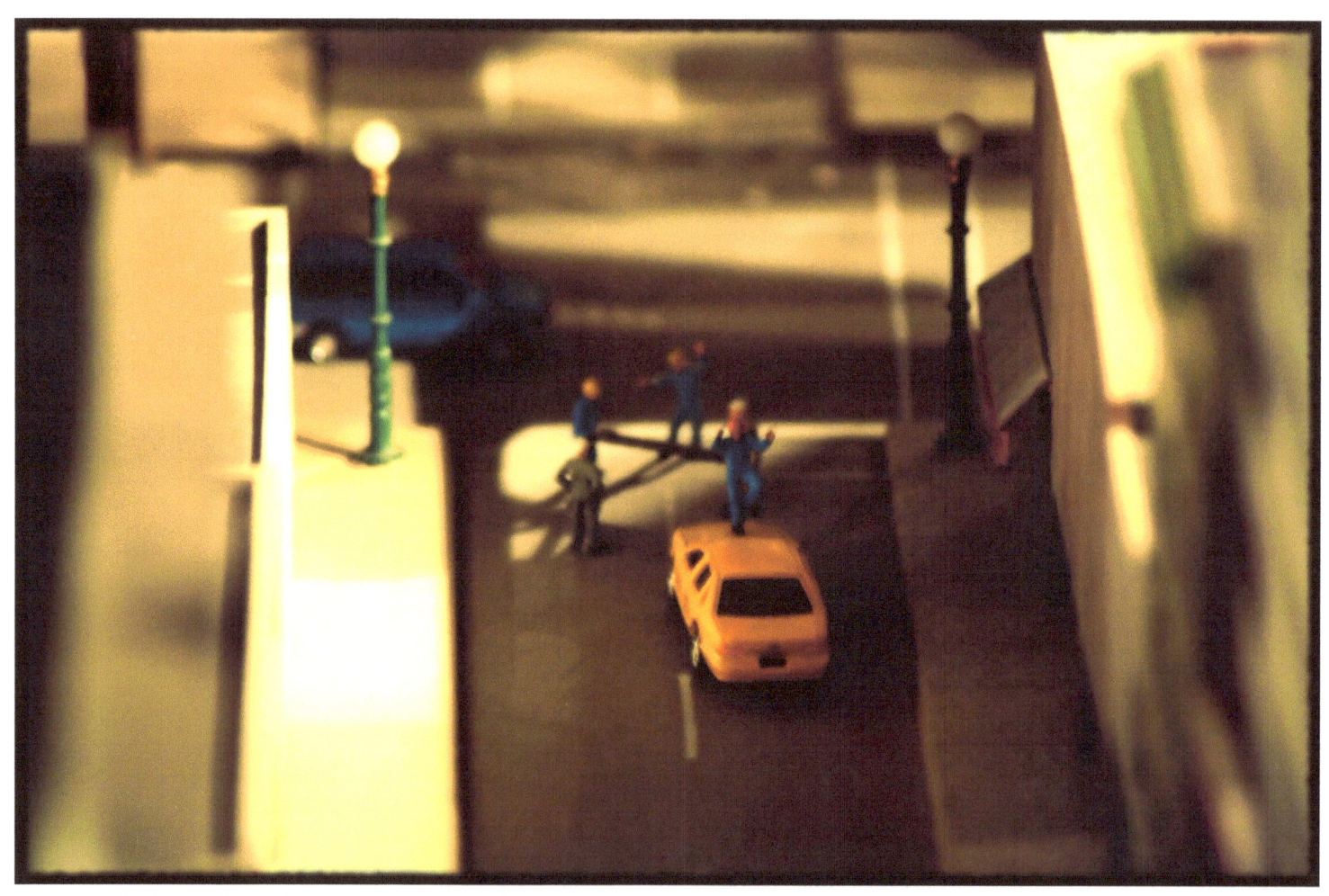
This is because they are meaningless to each other.

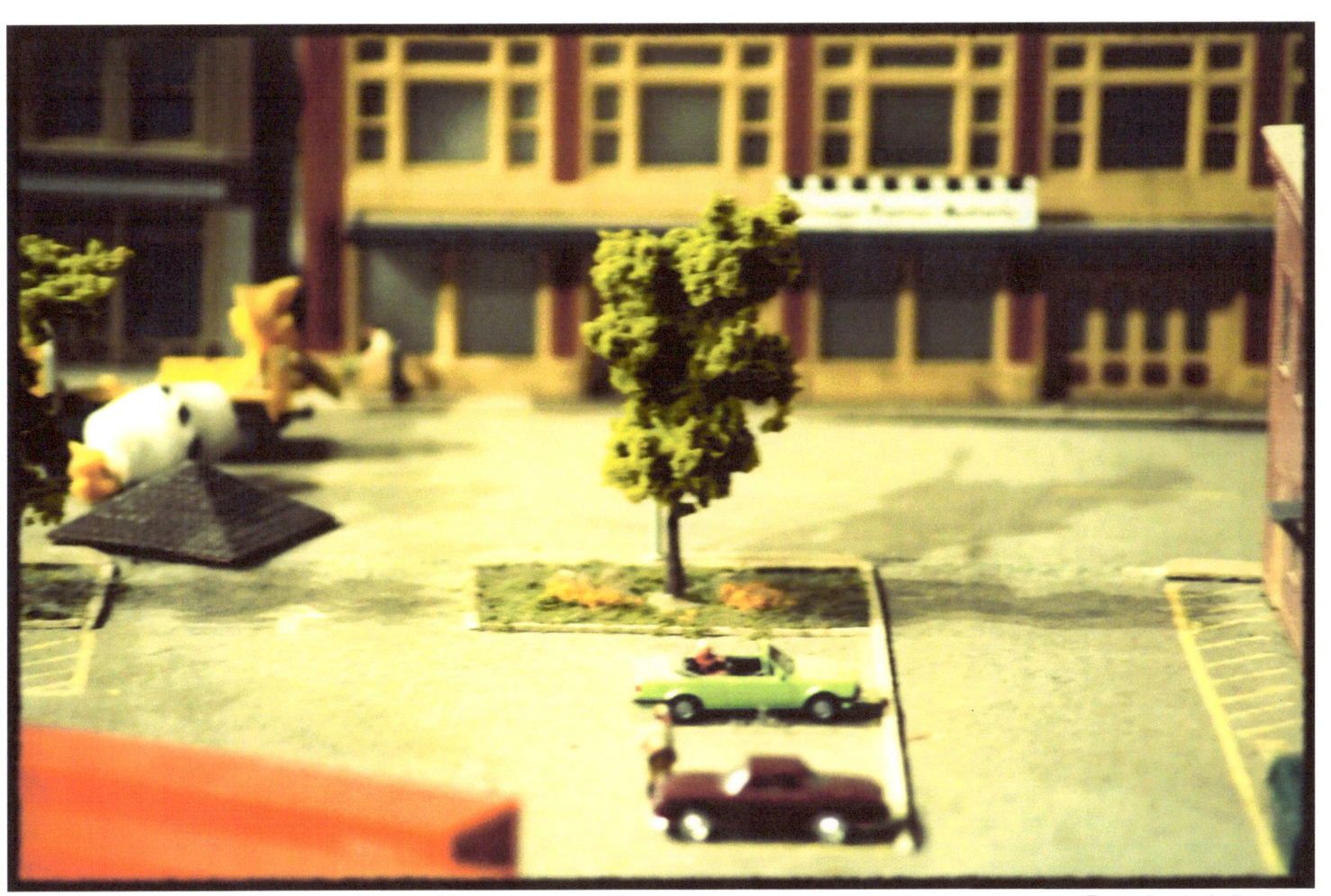

The fruit of only one tree was forbidden.

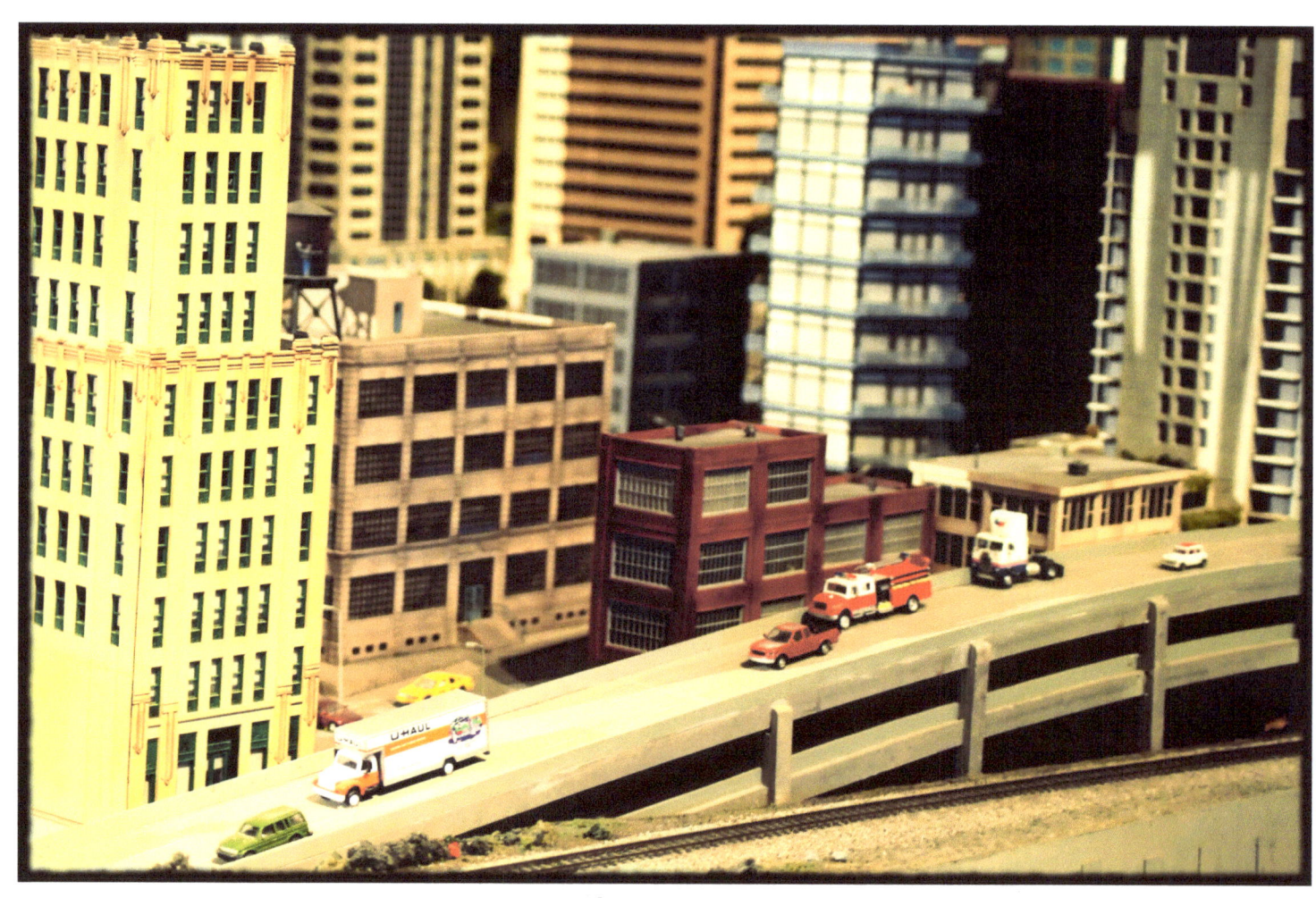

They are all true or all false.

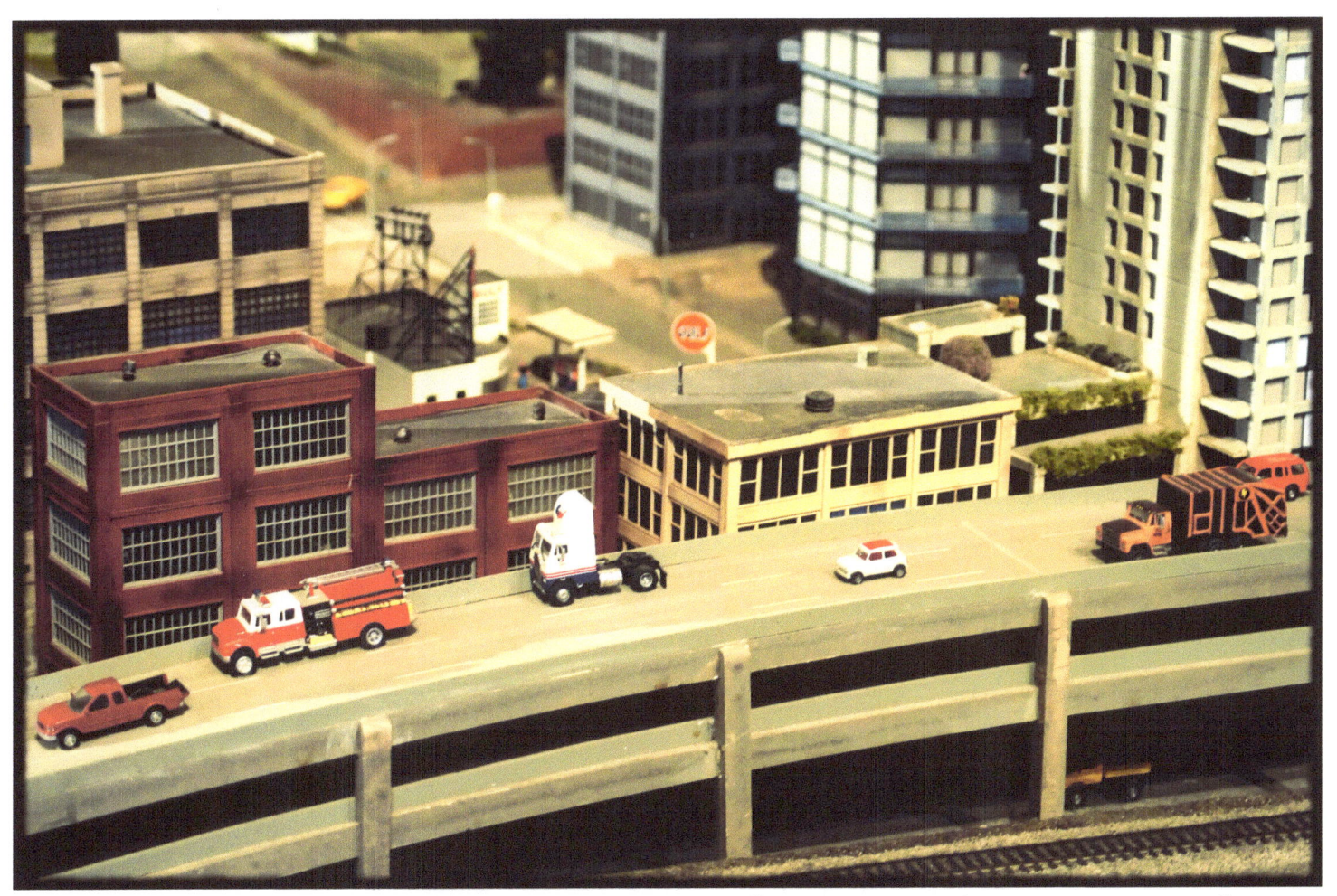

The concept of size exists on a plane that is itself unreal.

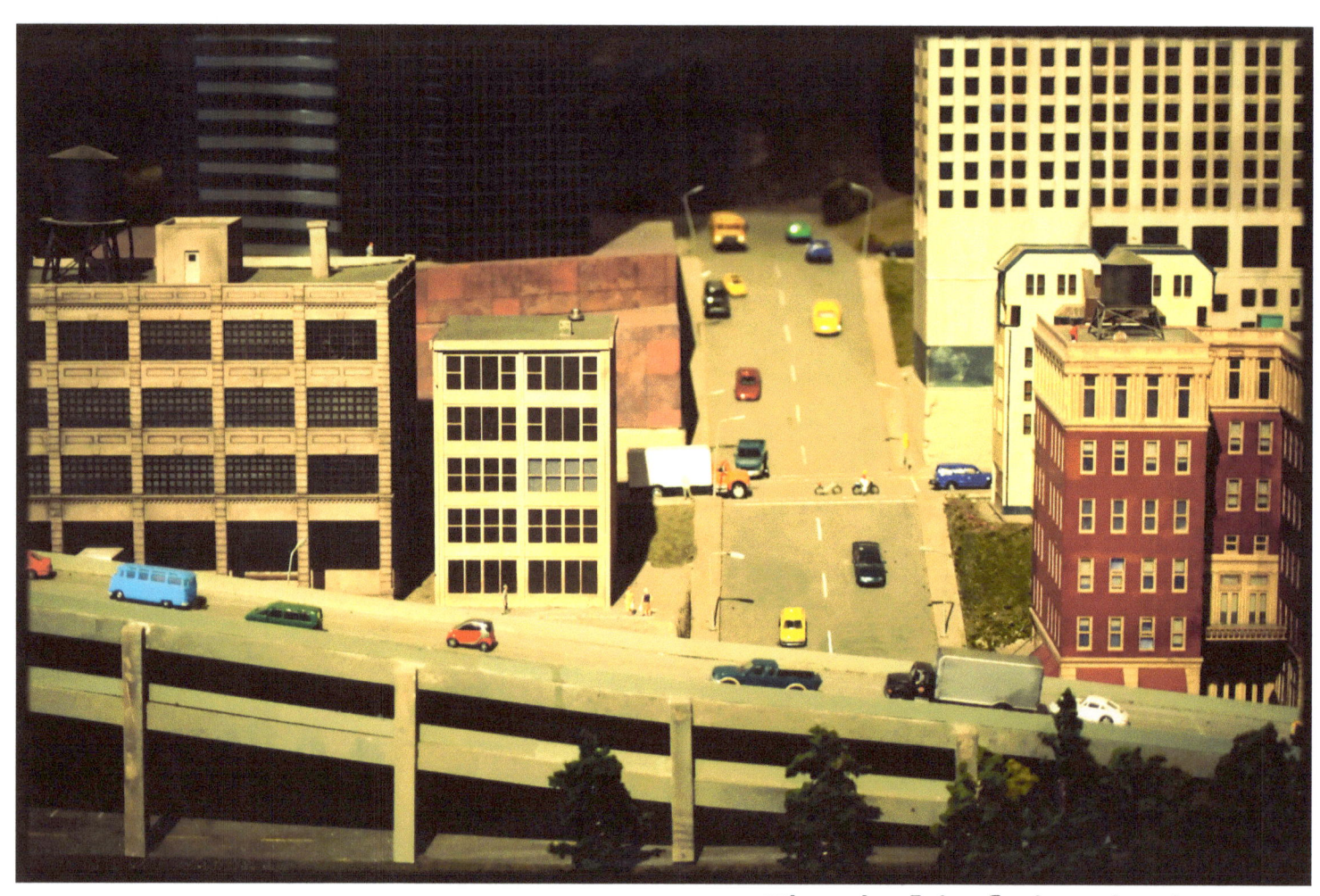

The belief in darkness.

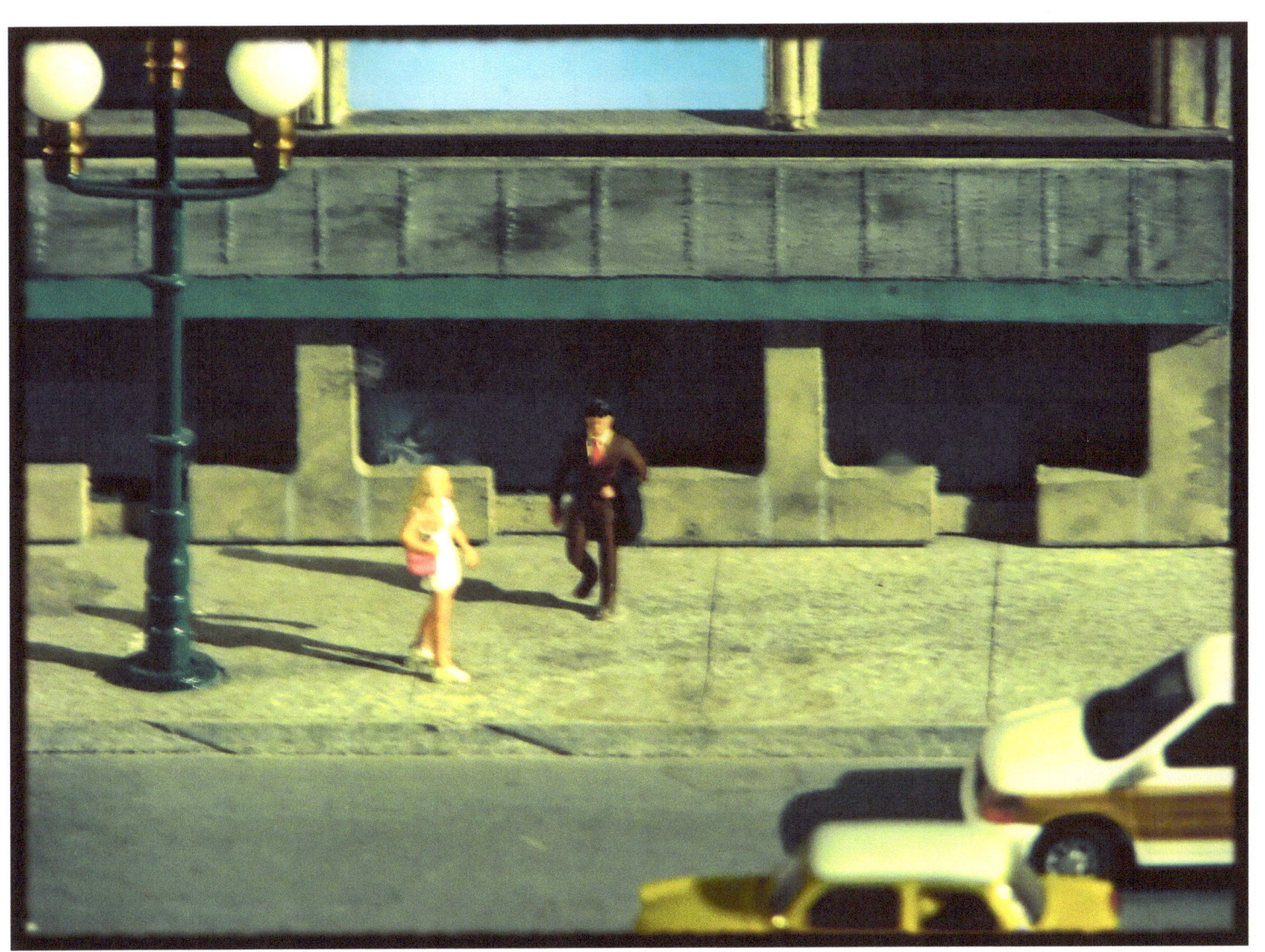
He believes that in some way he needs it.

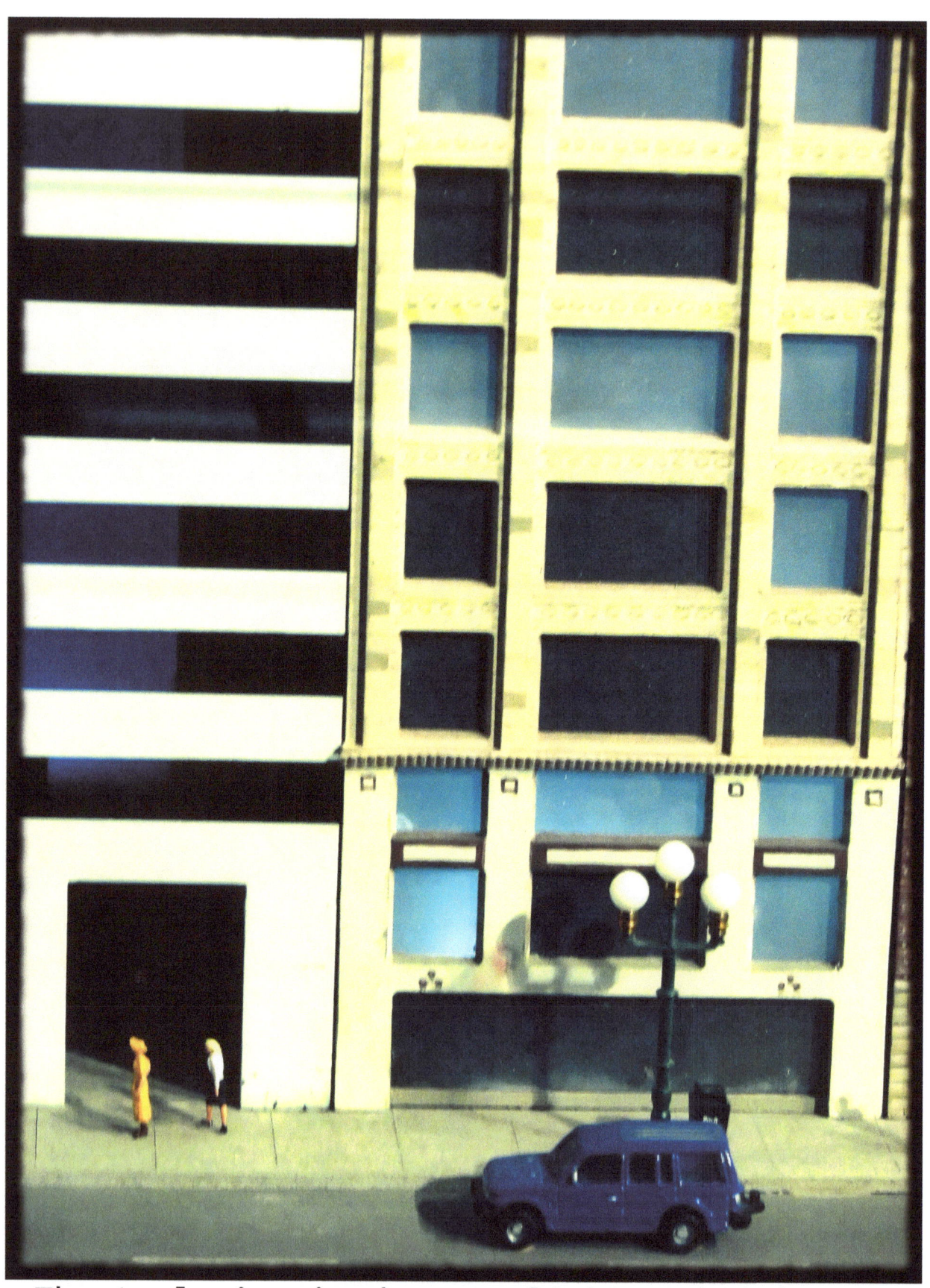

The truly inspired are enlightened and cannot abide in darkness.

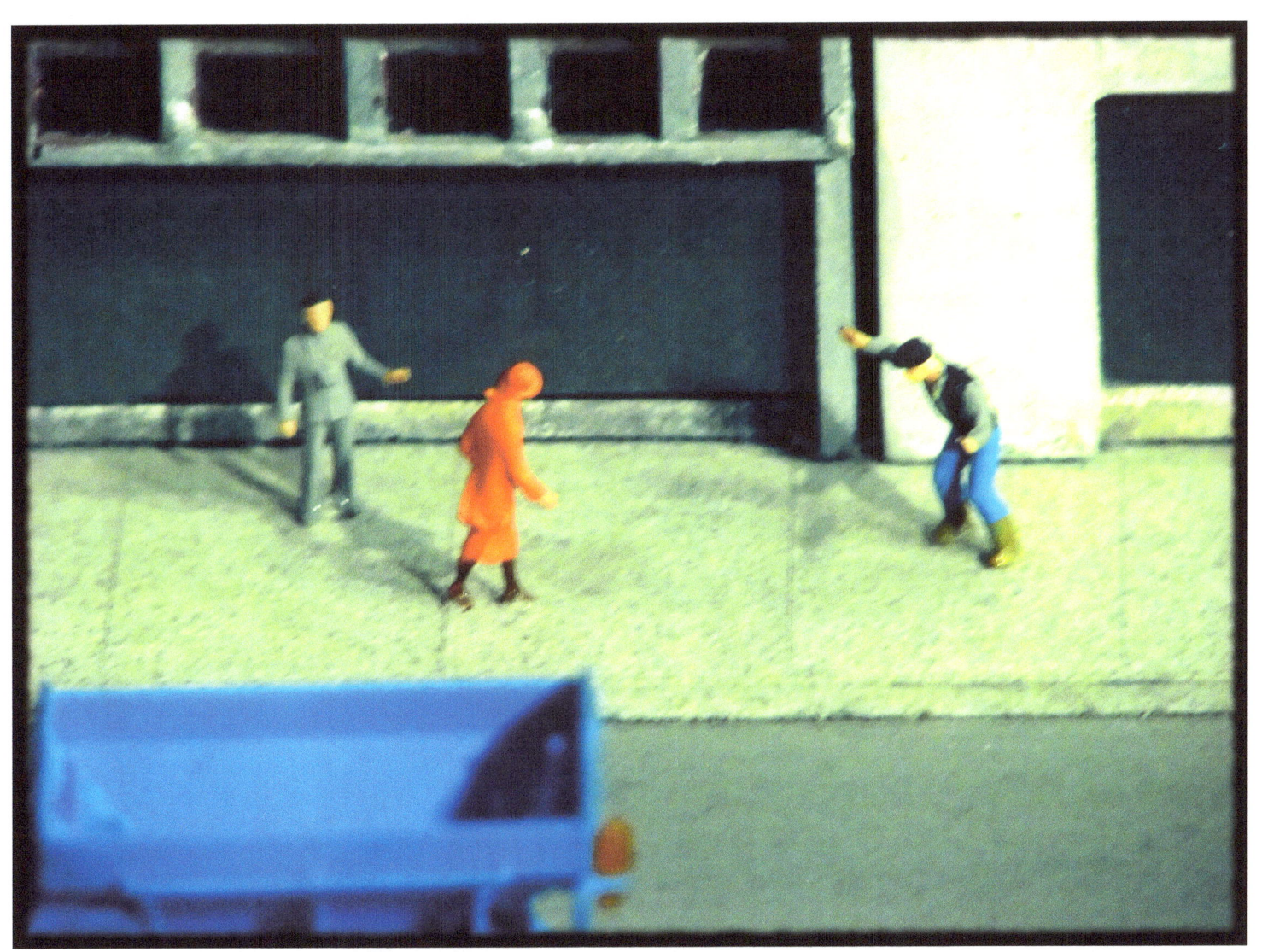
Good teachers never terrorize their students.

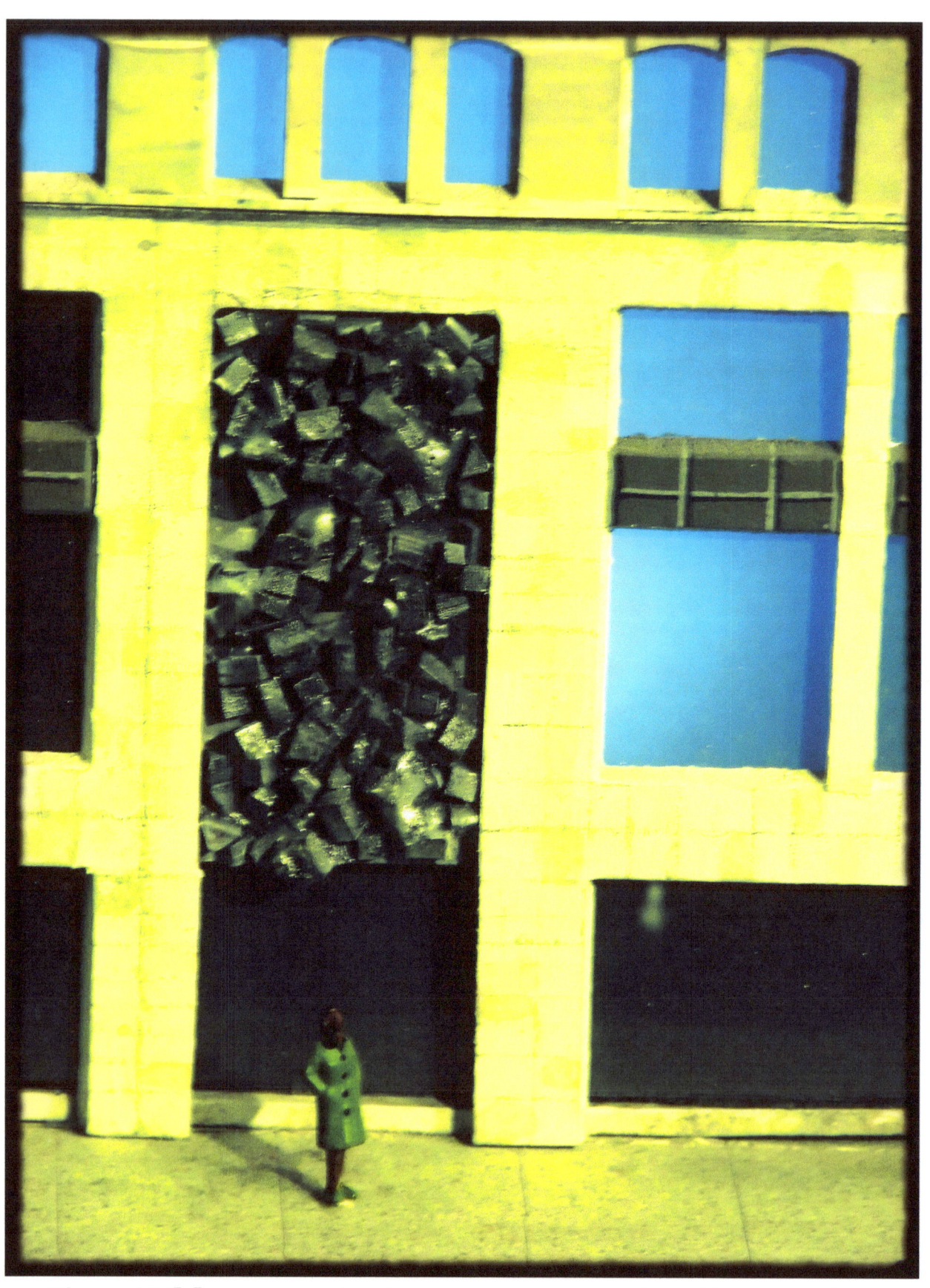

The difference between us now is that I have nothing else.

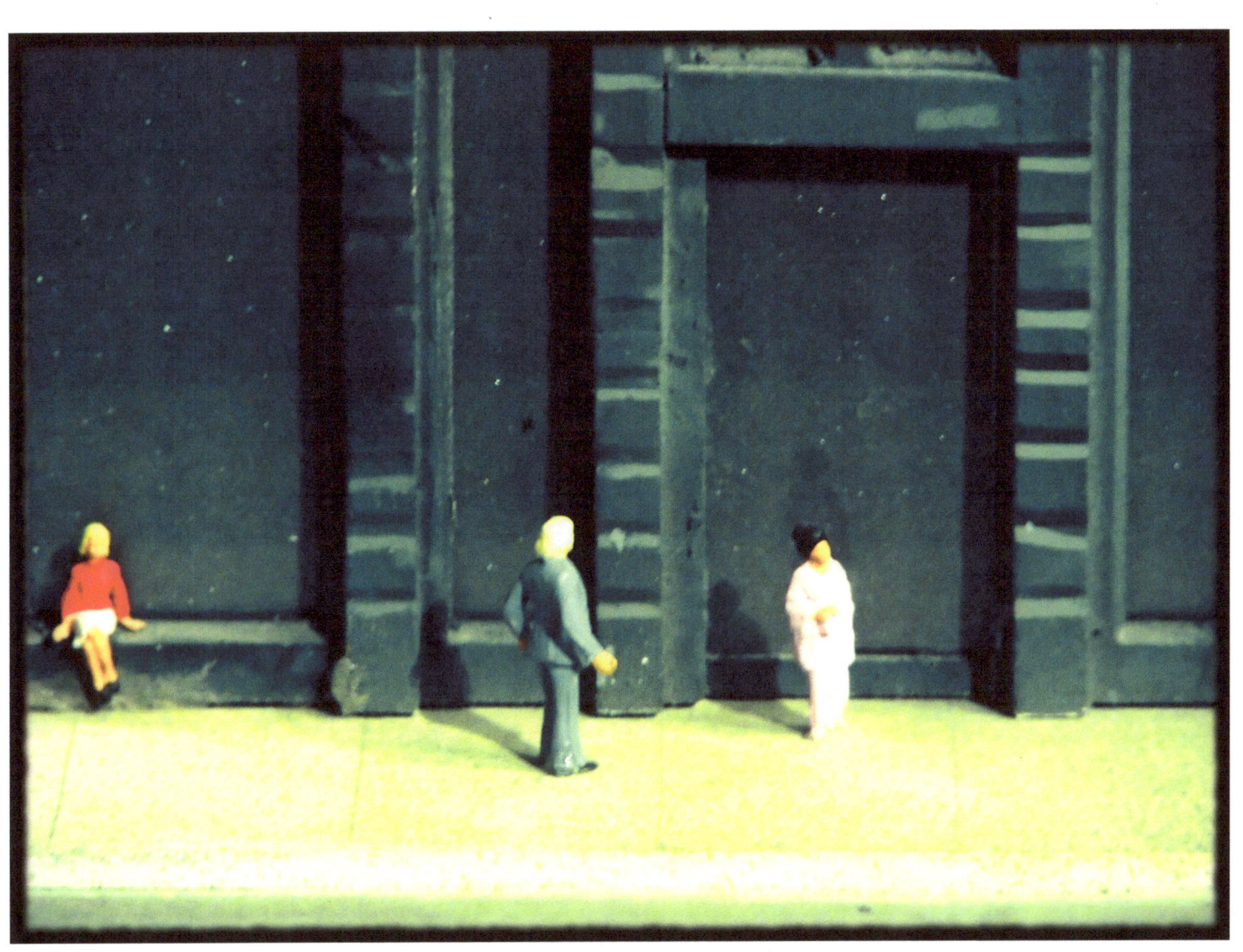

Let us wait here in silence.

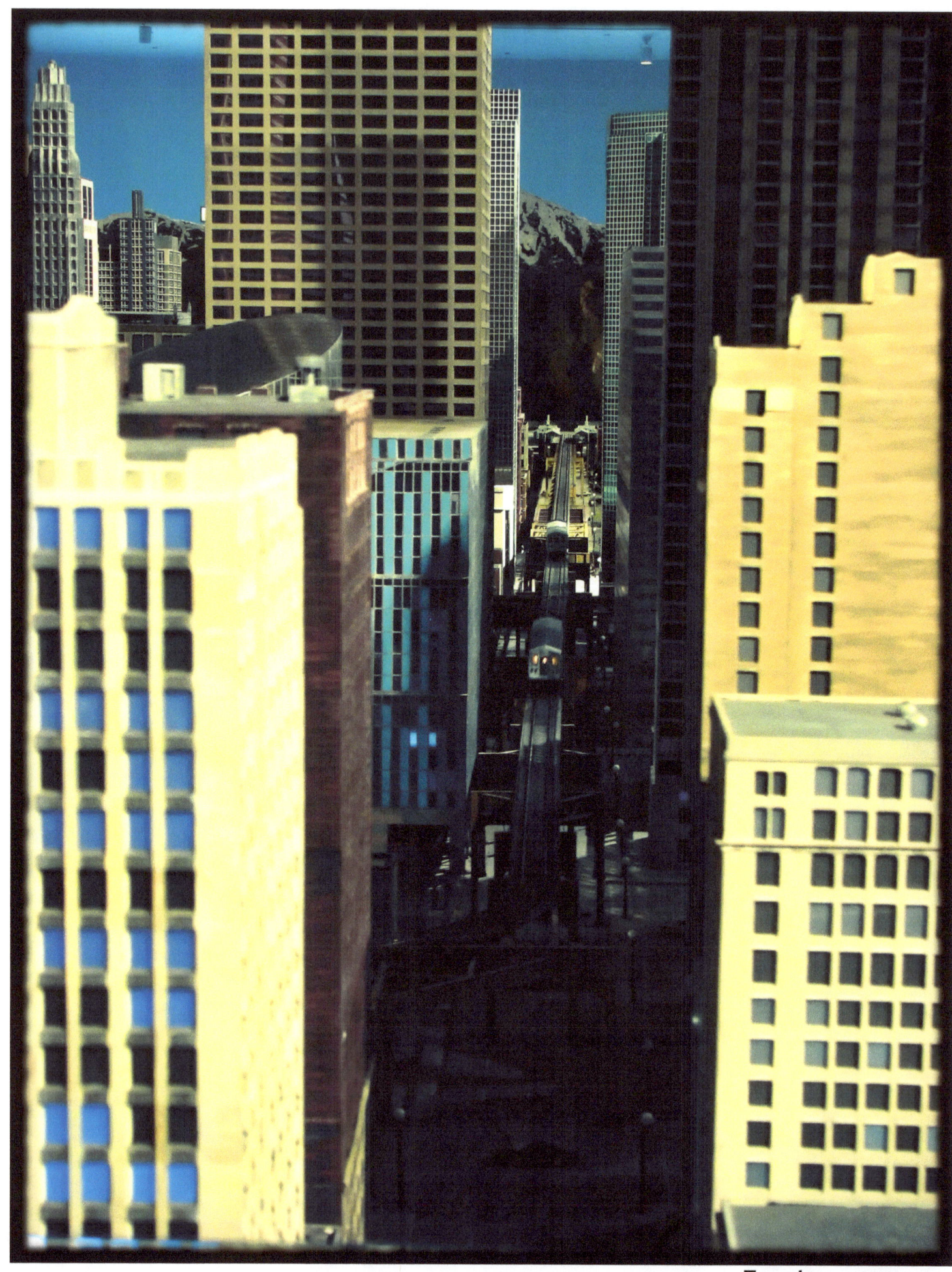

Empty space.

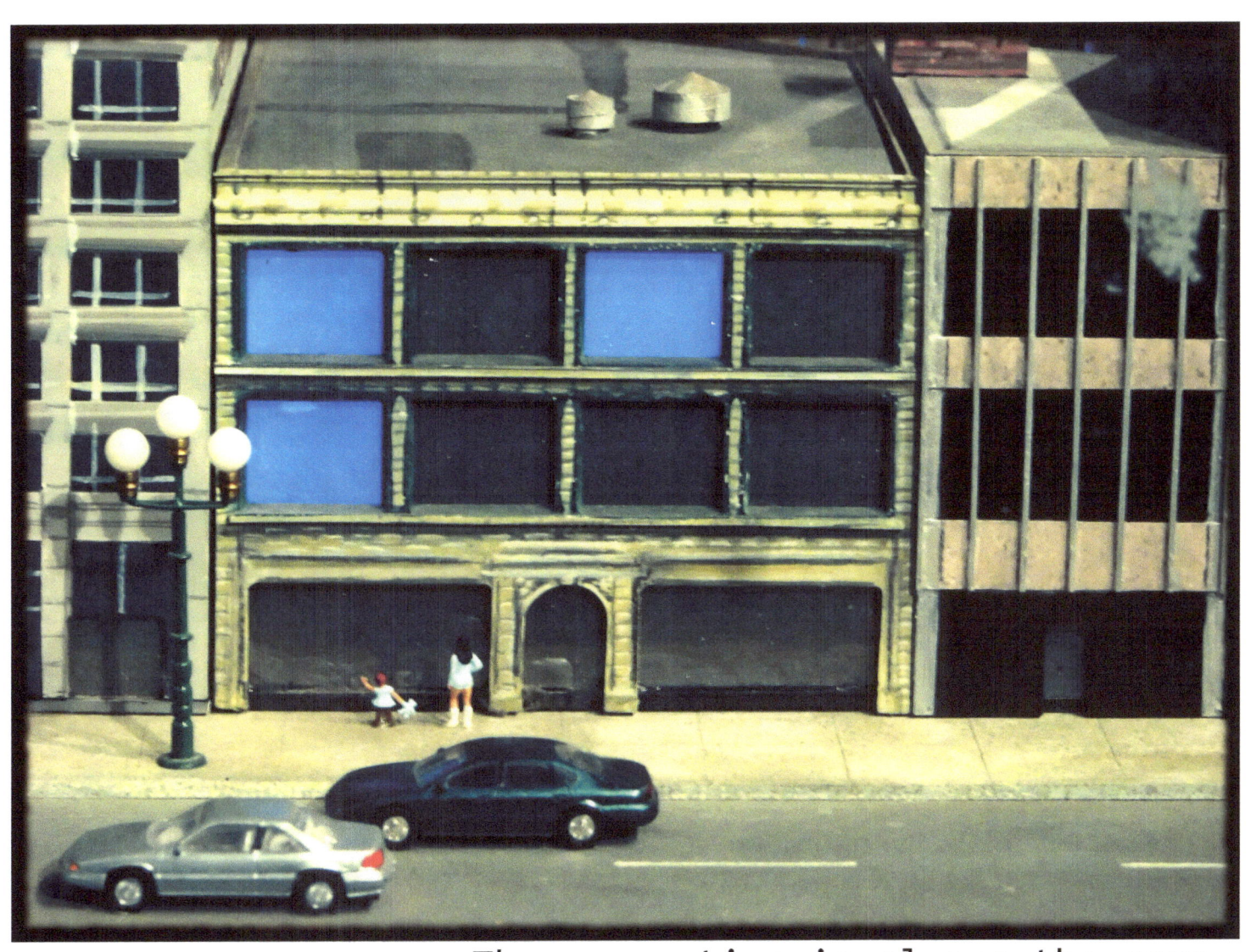

The correction is always the same.

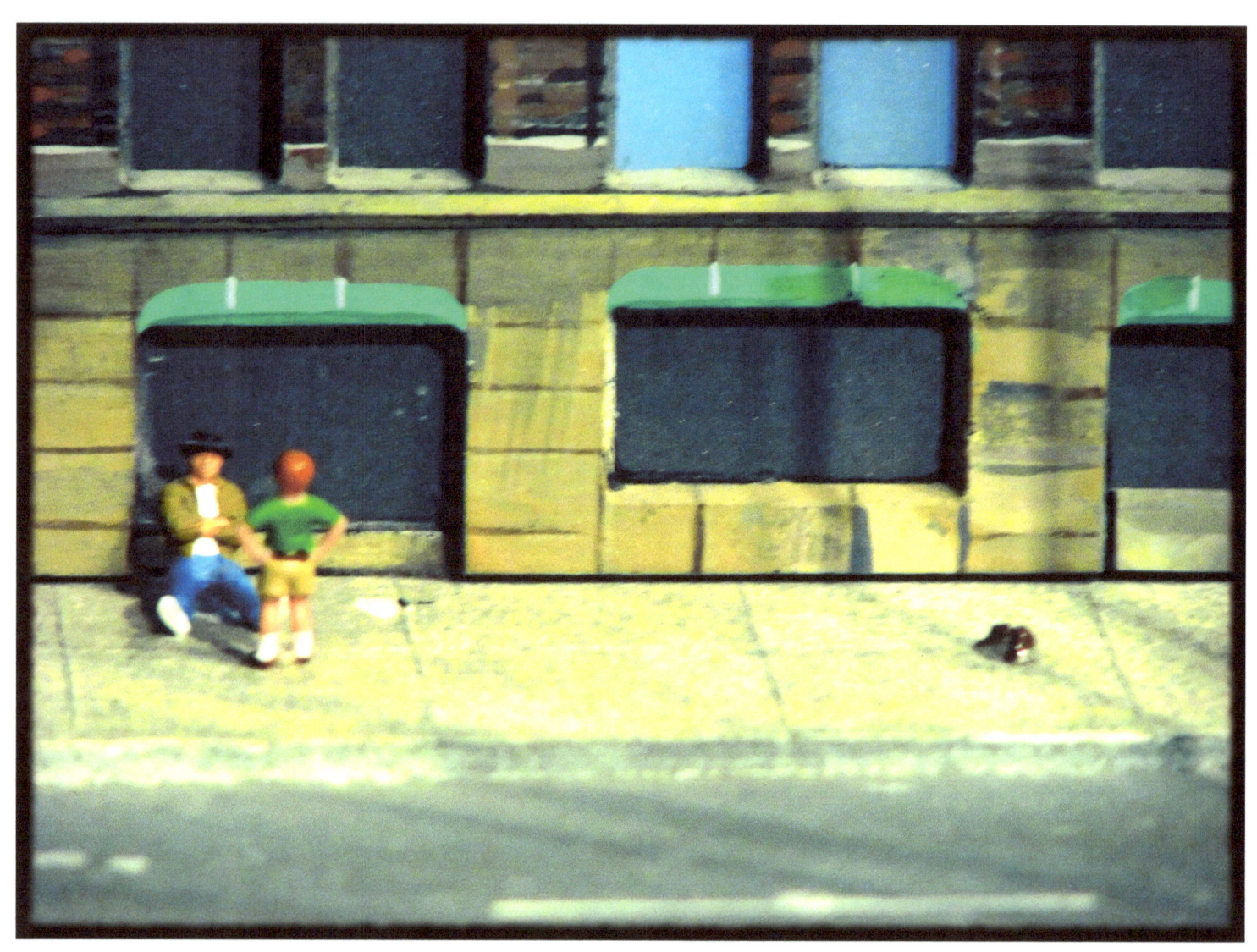

The devil deceives by lies.

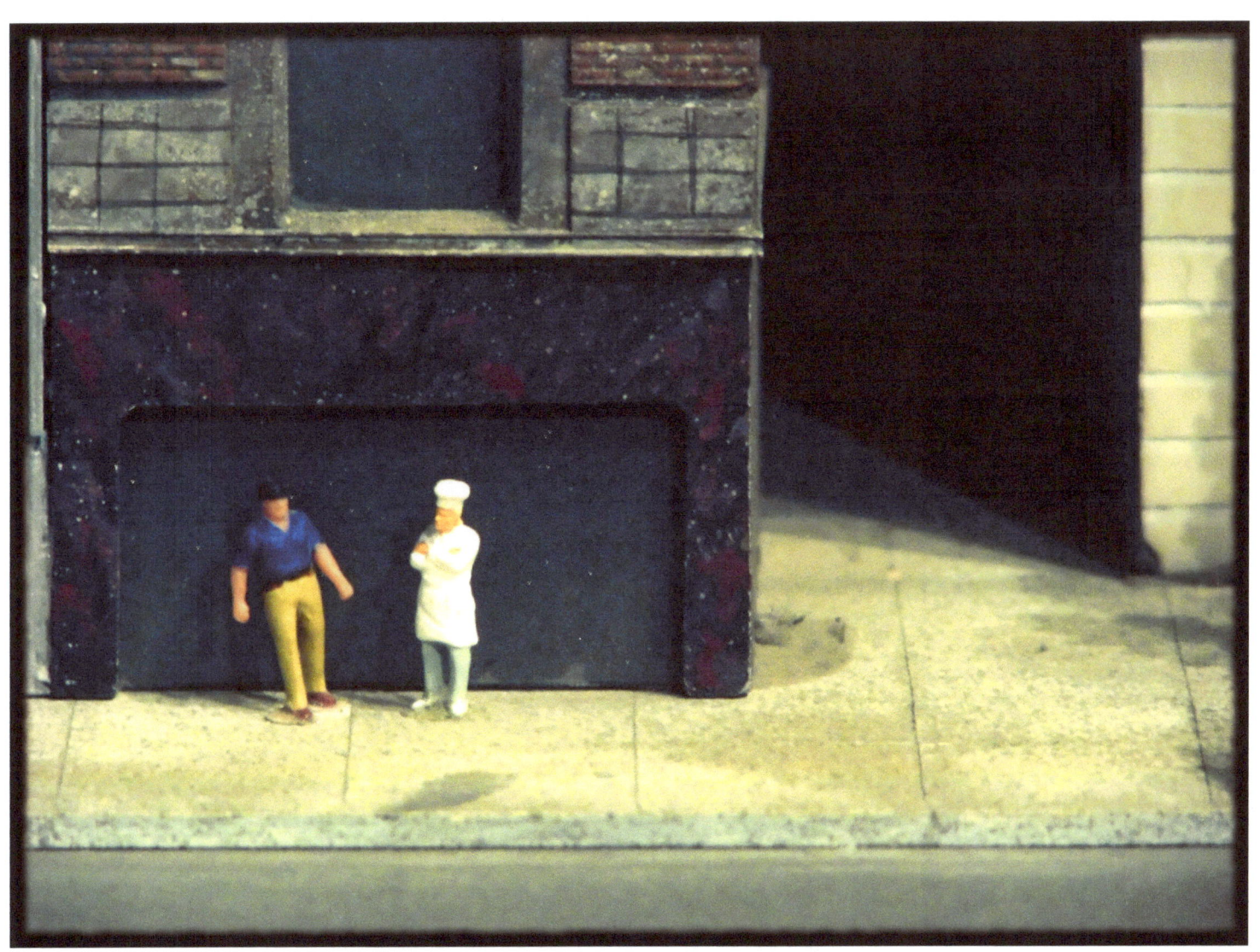

He is concerned with the effect of his ego on other egos.

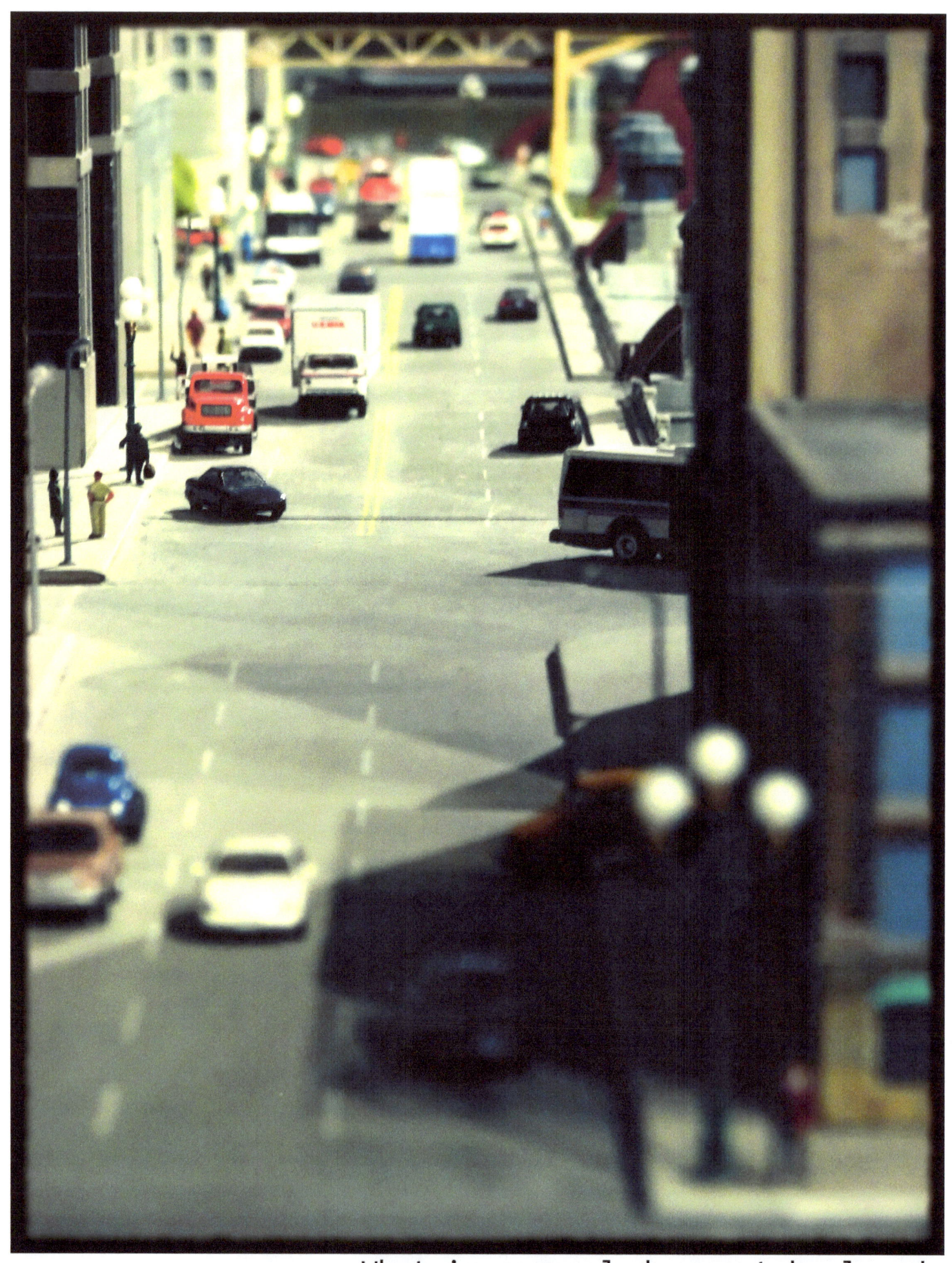

What is concealed cannot be loved.

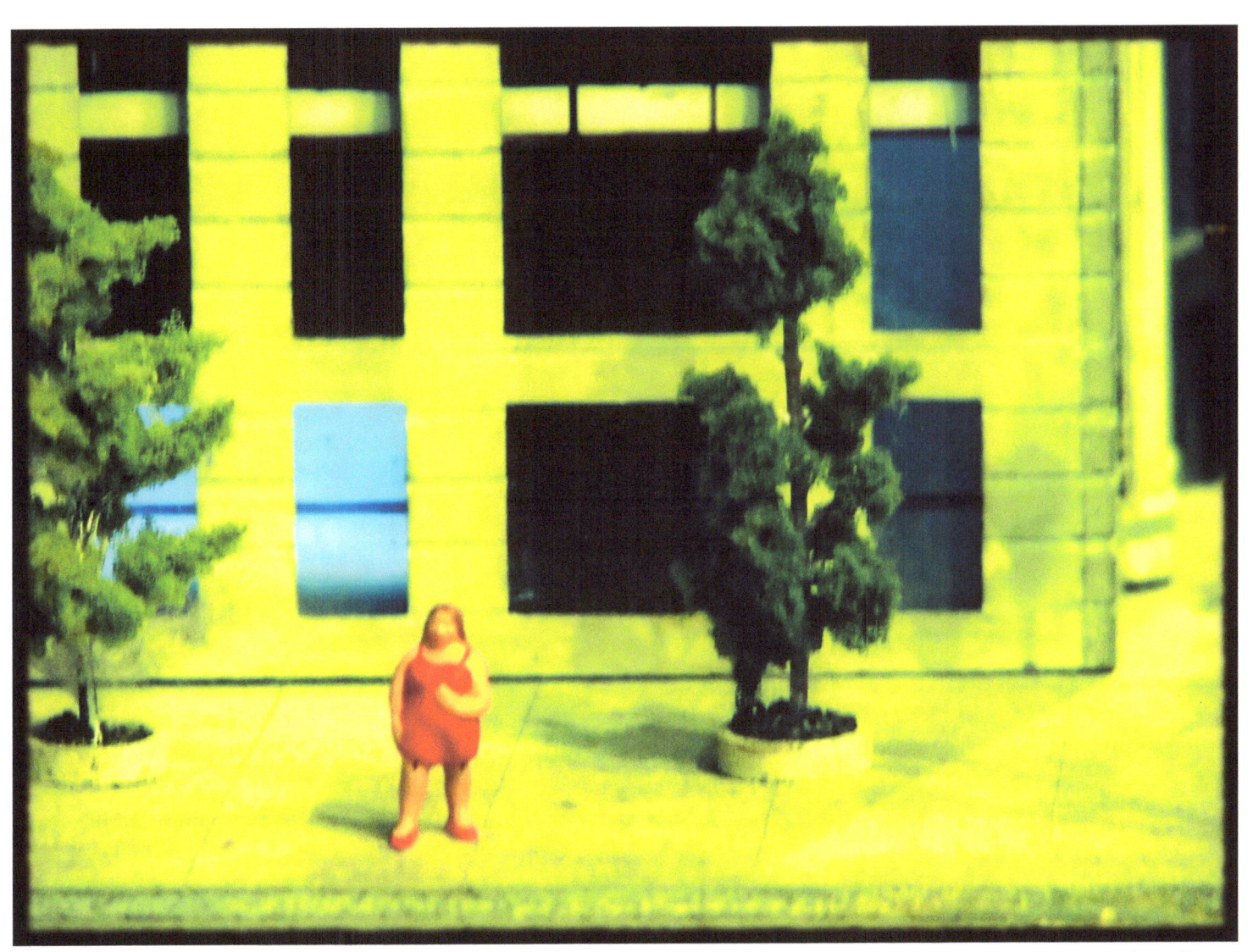
The illusion of love will never satisfy.

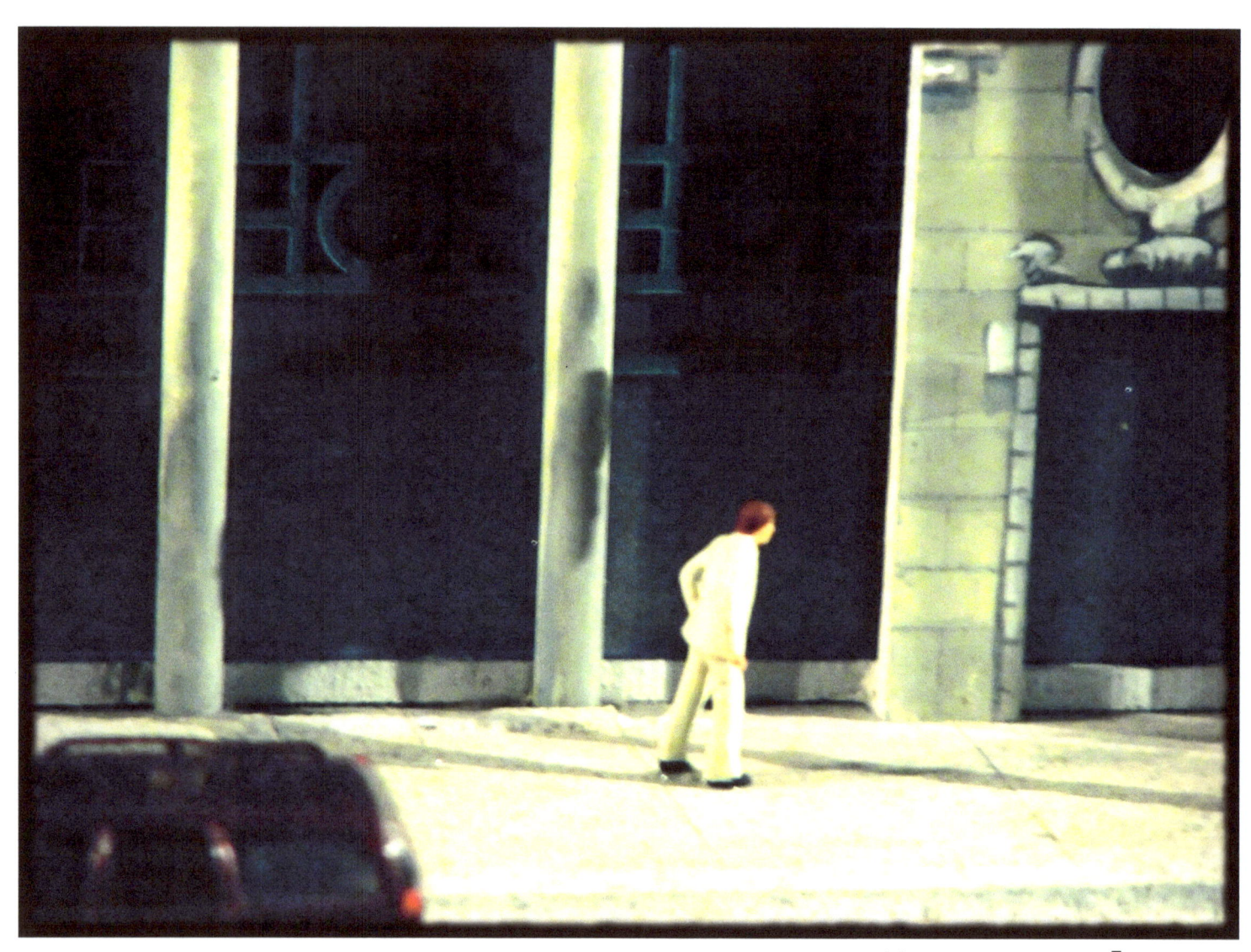

He never sleeps.

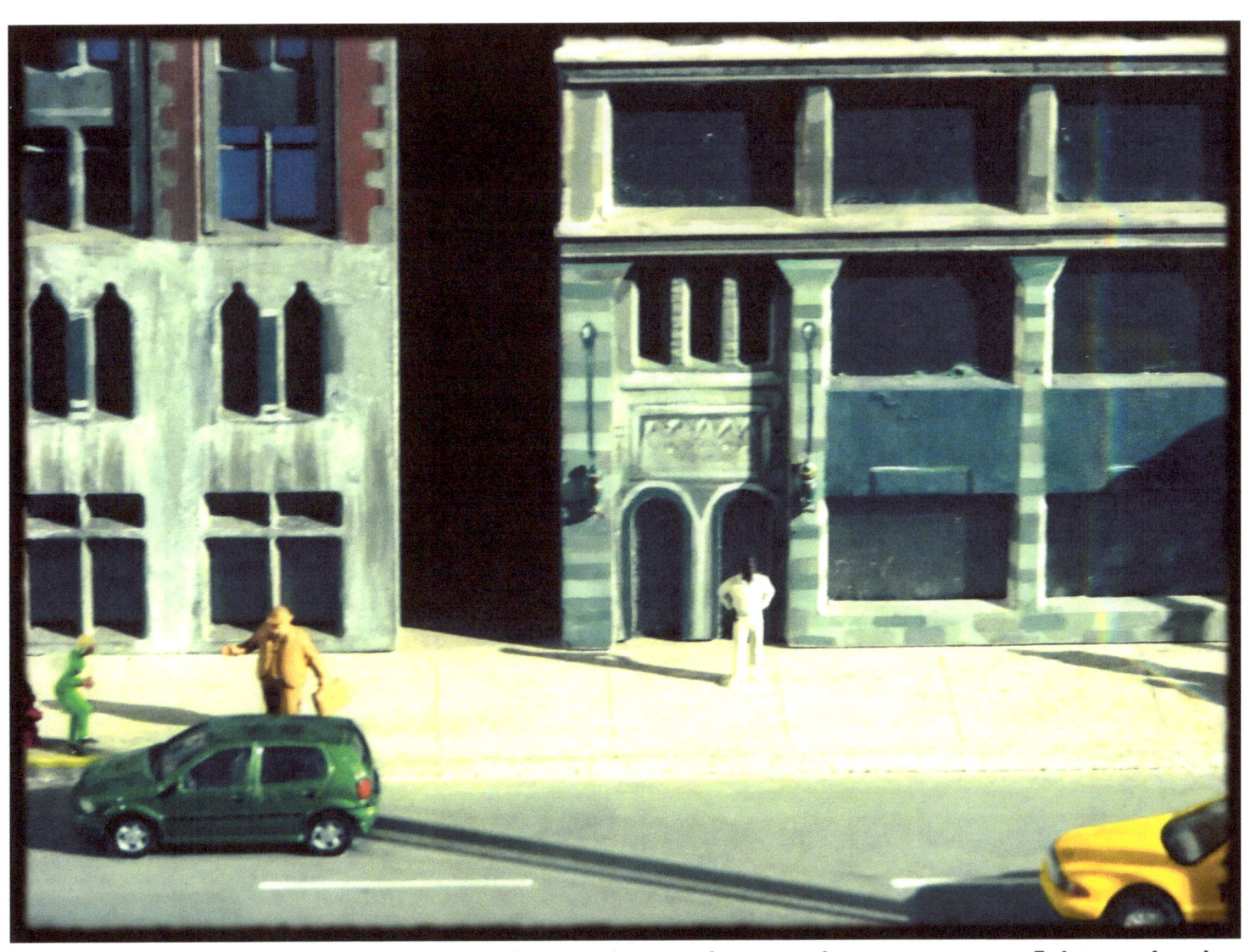

Choosing depends on a split mind.

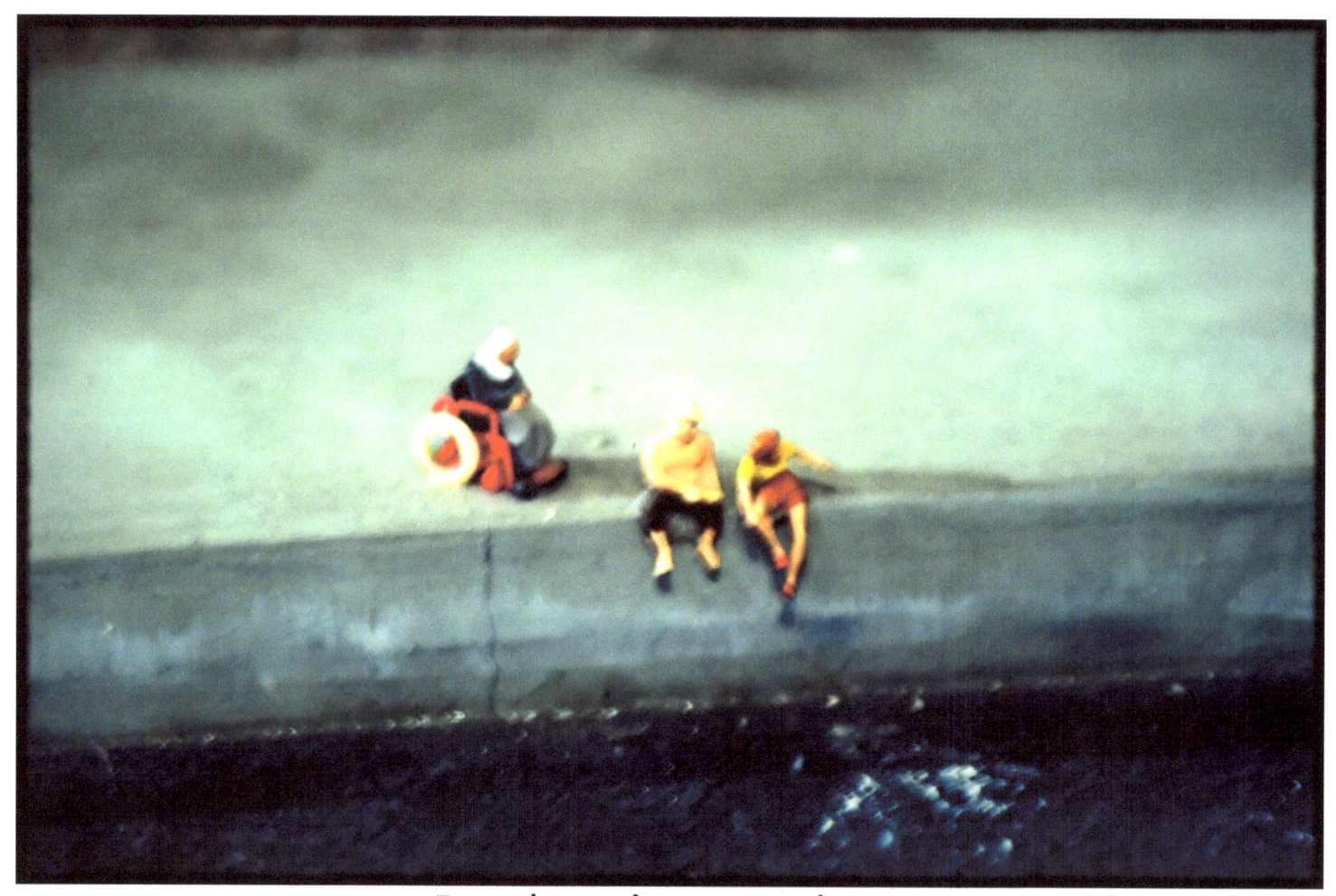
By choosing one he gave up the other.

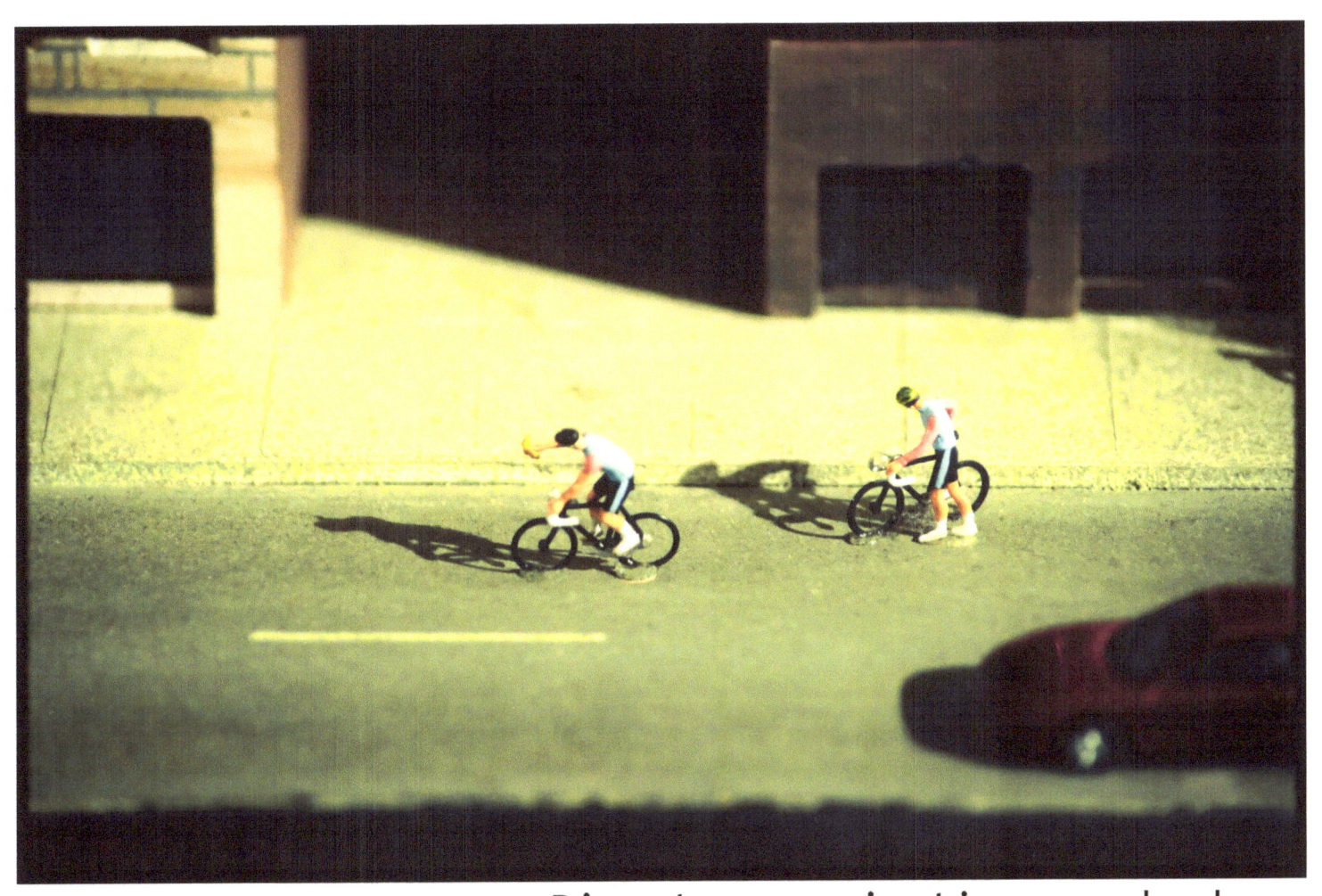

Direct communication was broken.

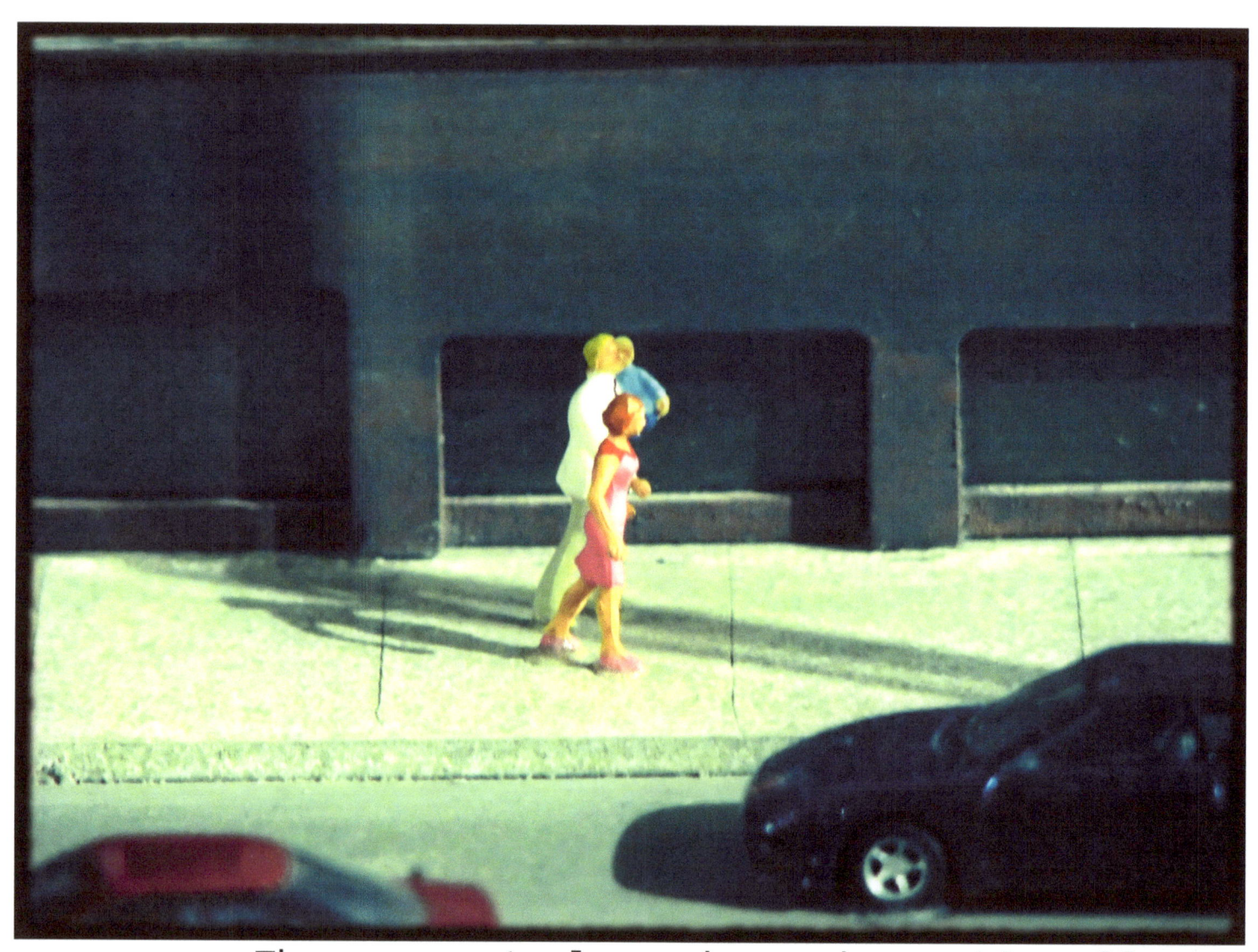
They may not always have observable effects.

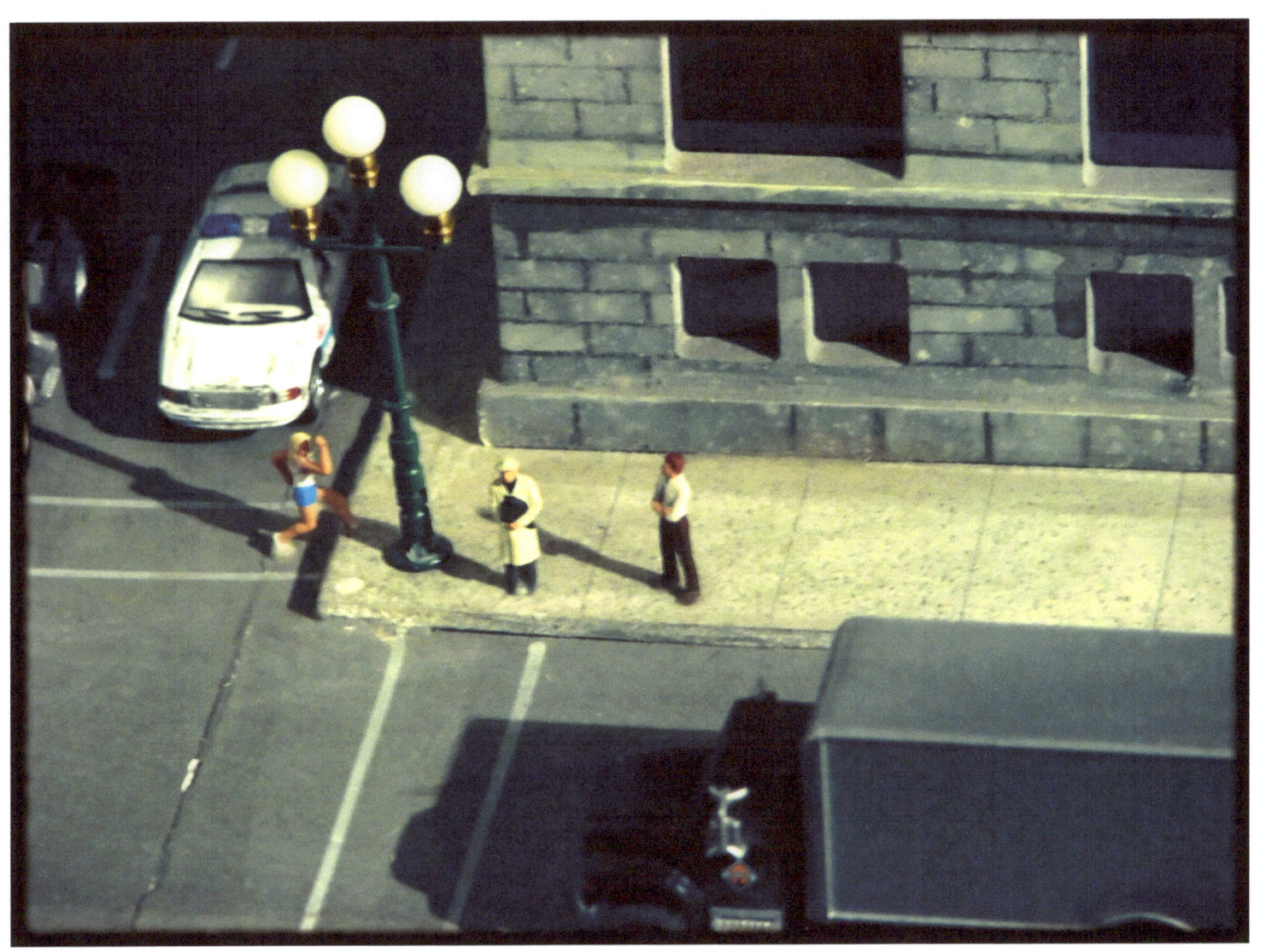

You will be told all you need to know.

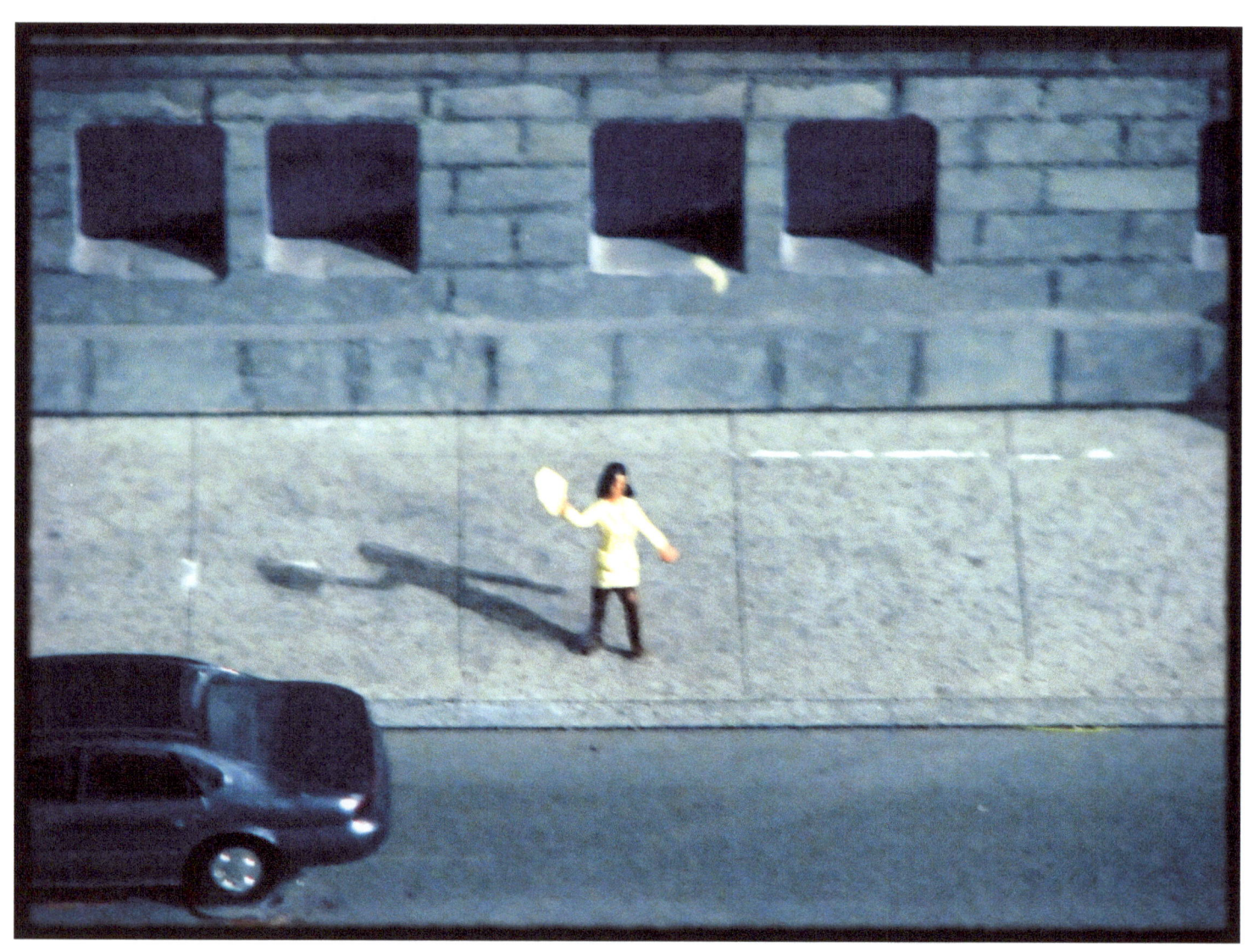

Be not afraid.

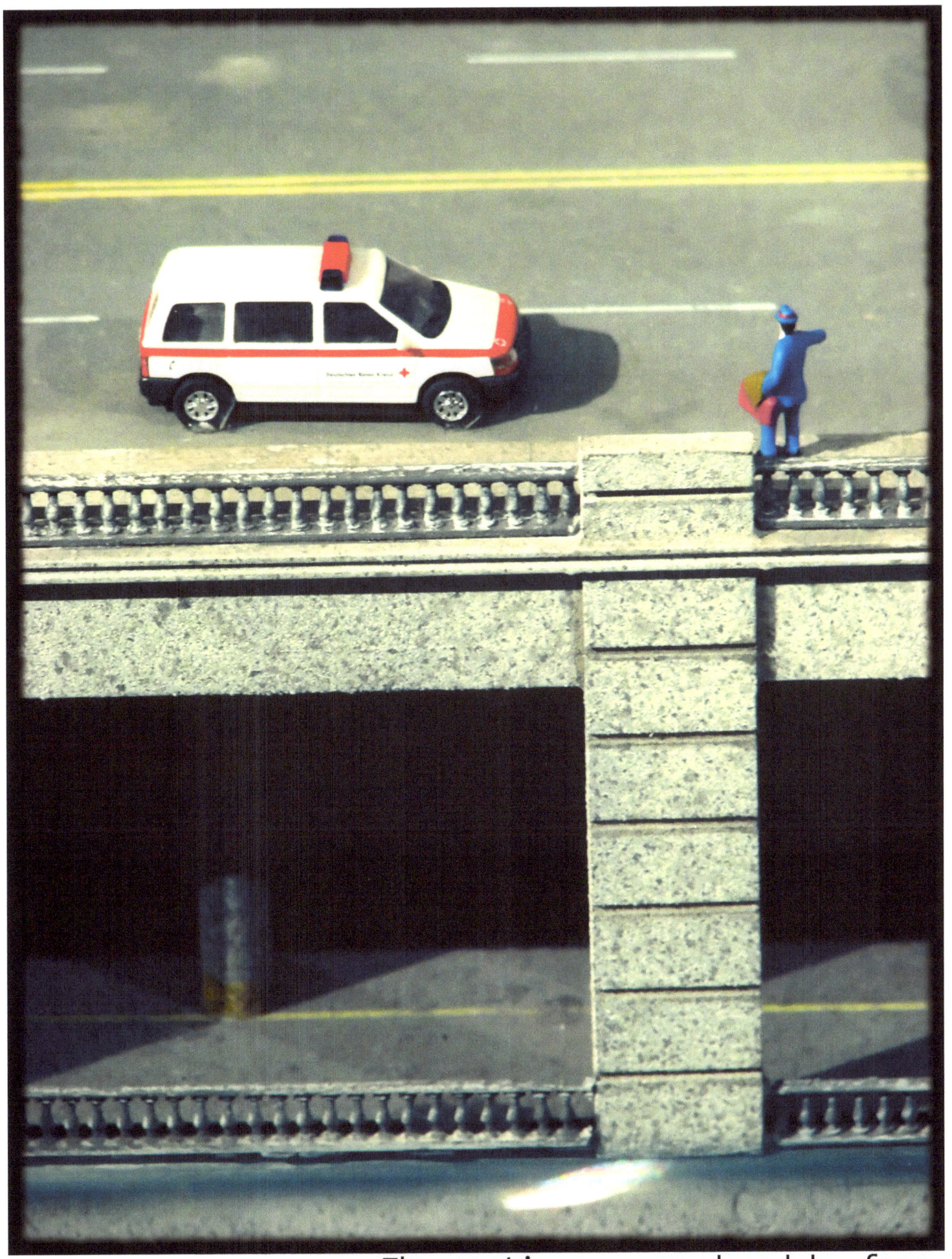
The emptiness engendered by fear.

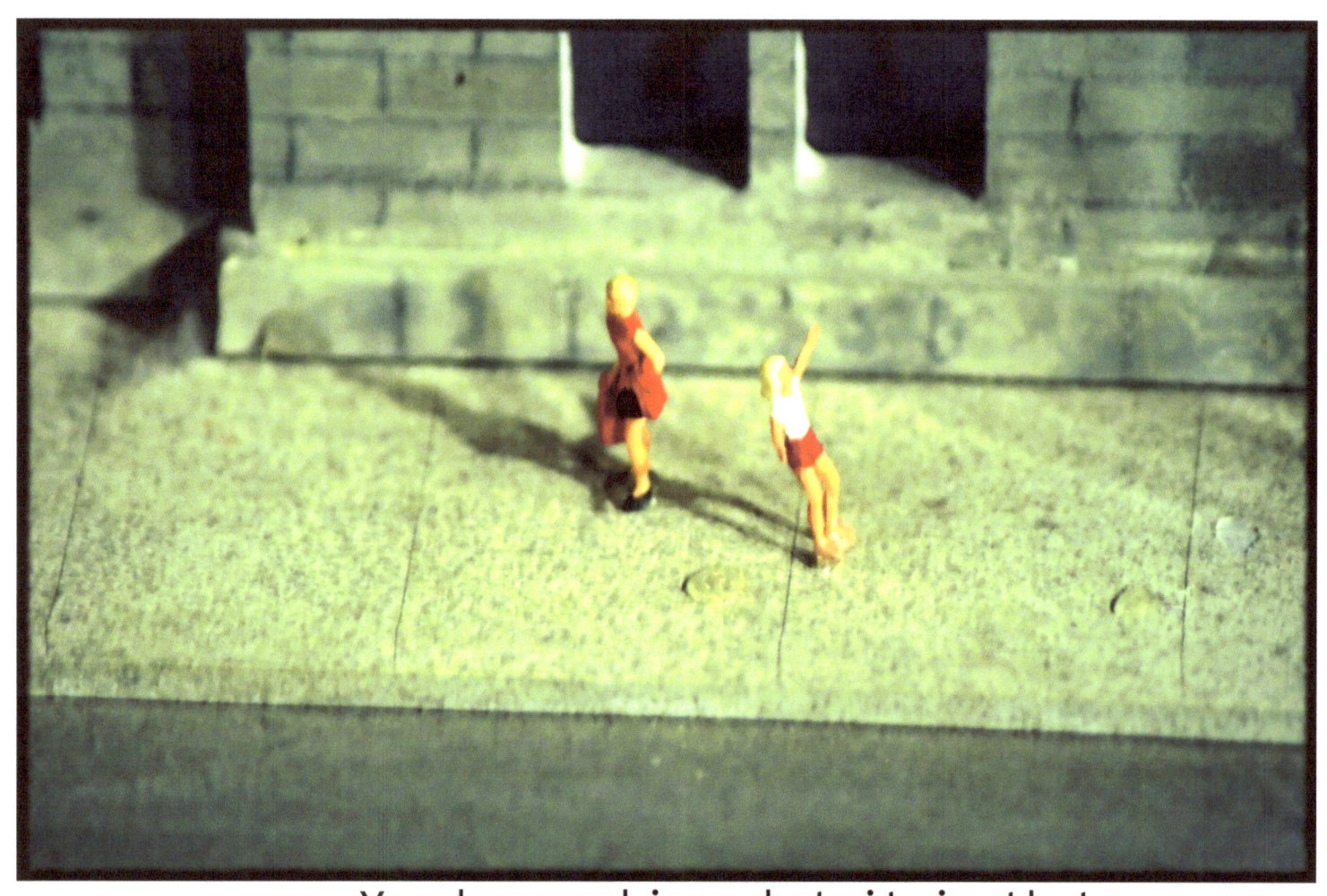
You keep asking what it is that you are.

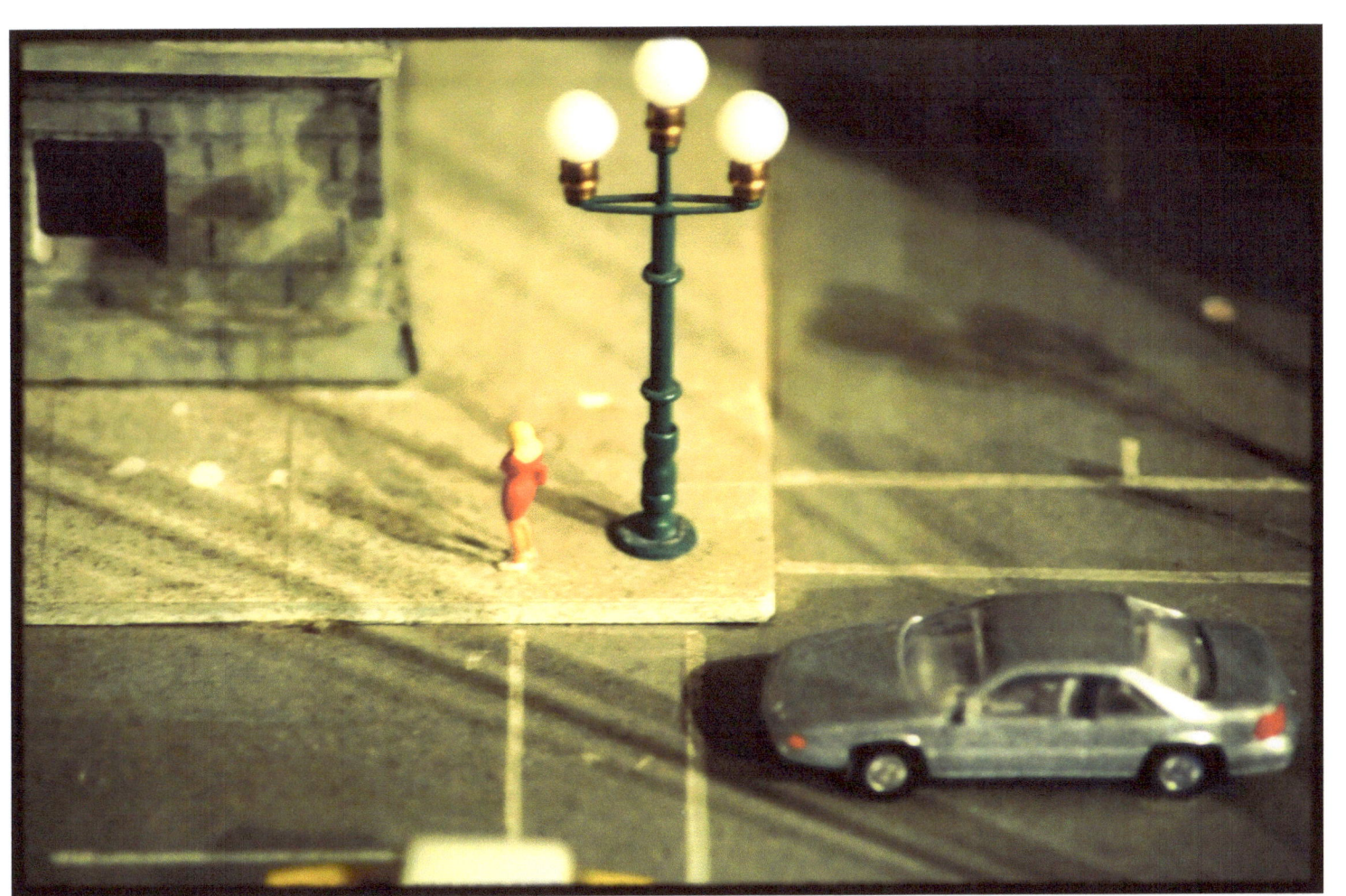

Love is expressed.

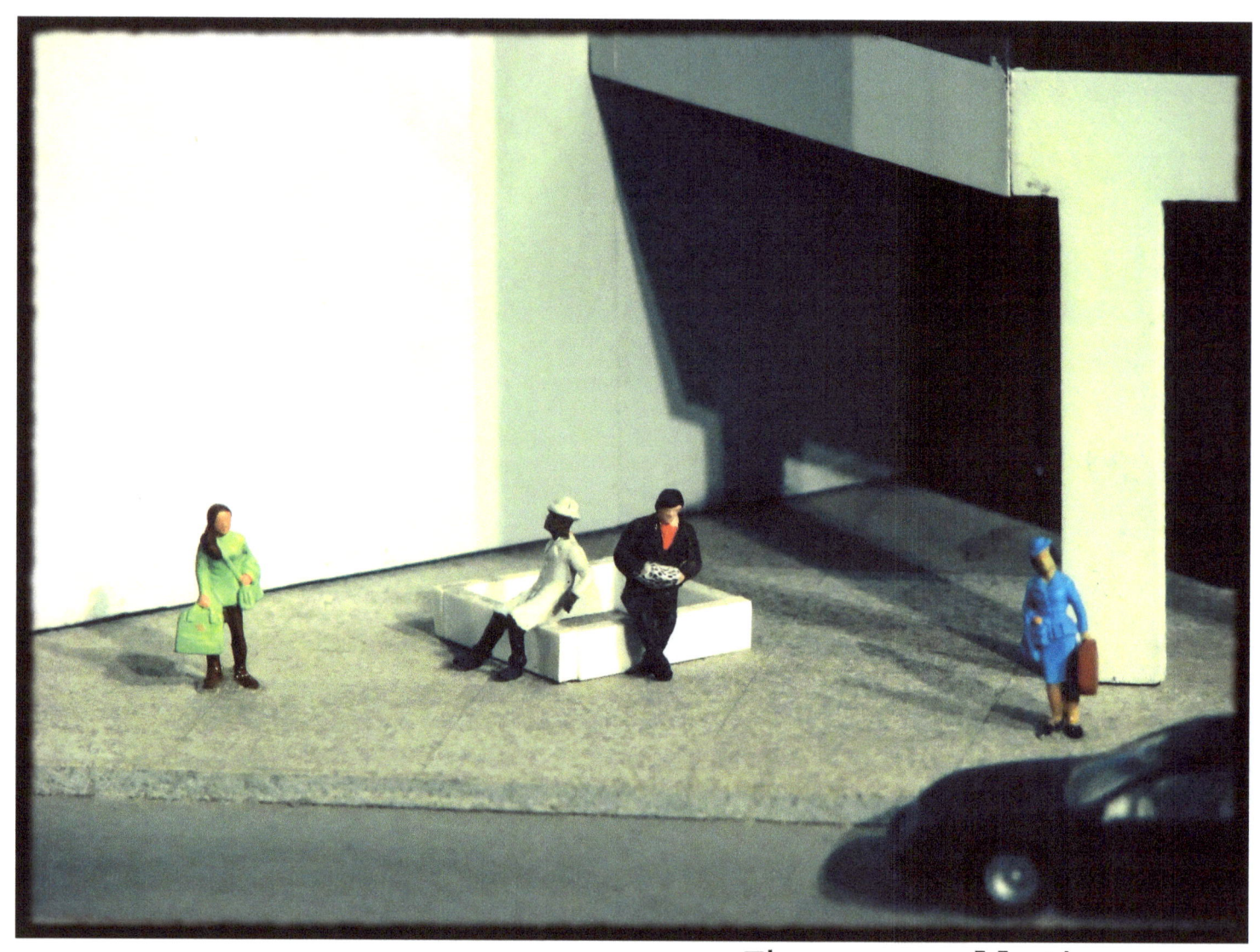

They are all the same.

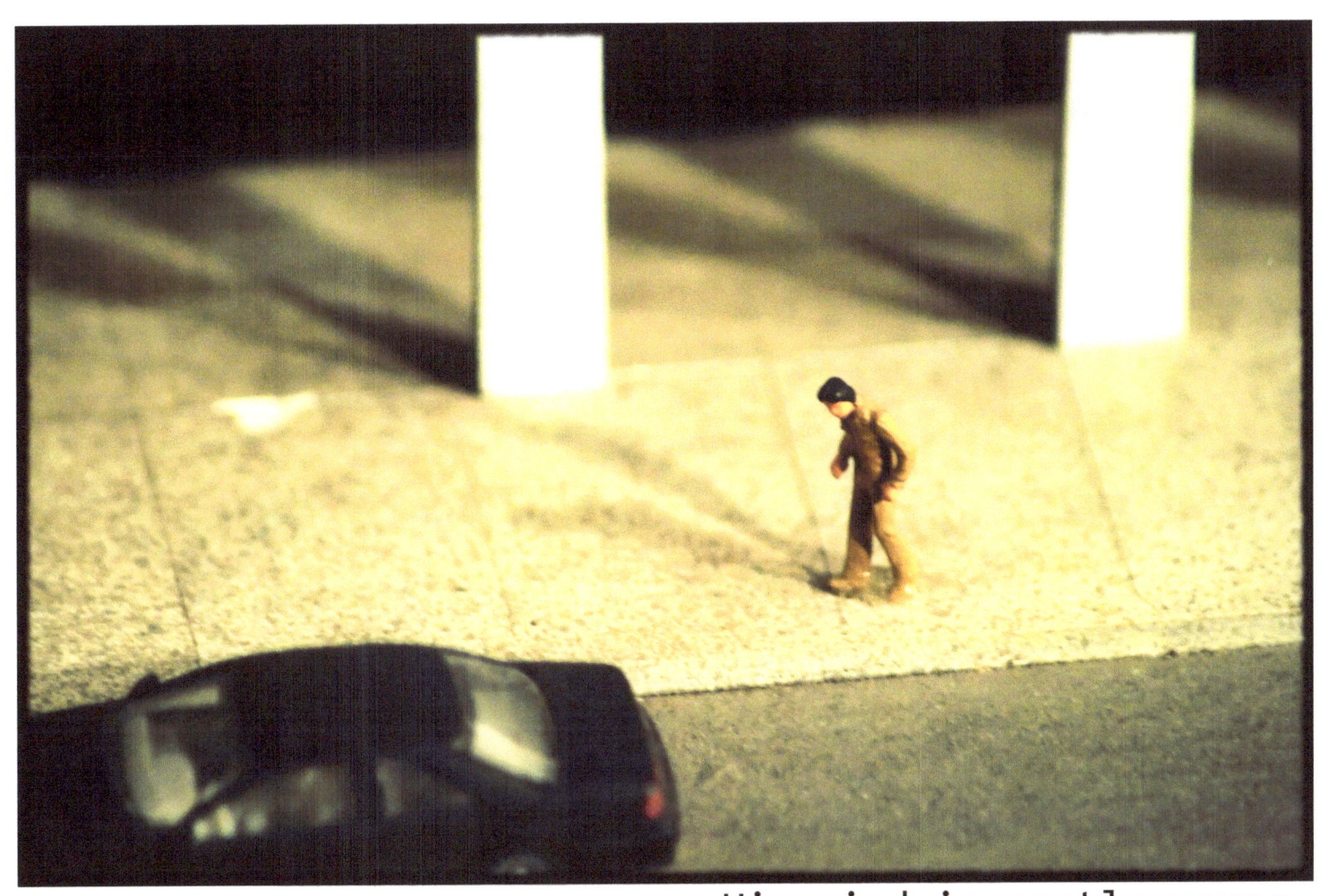

His mind is partly yours.

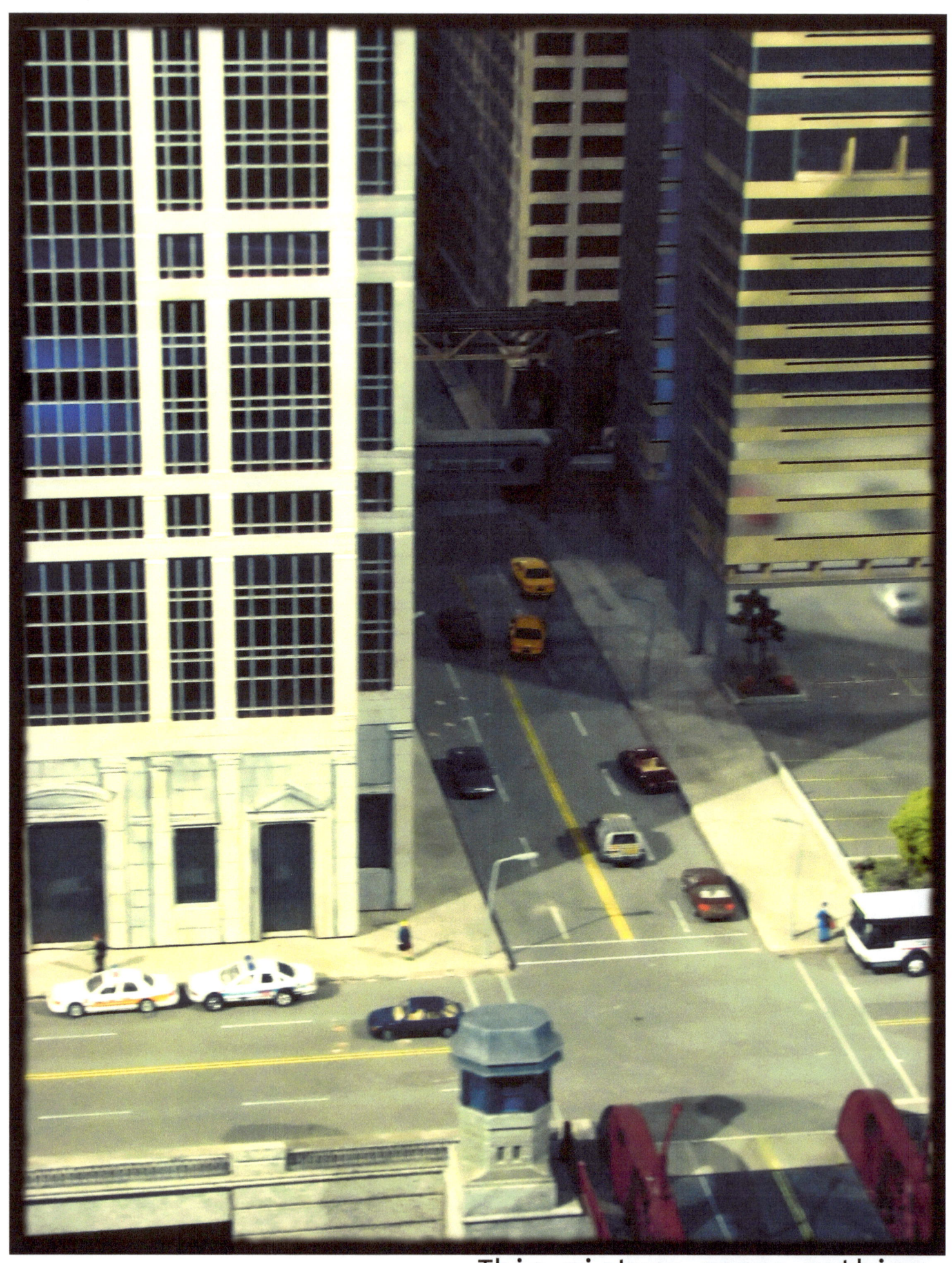

This picture means nothing.

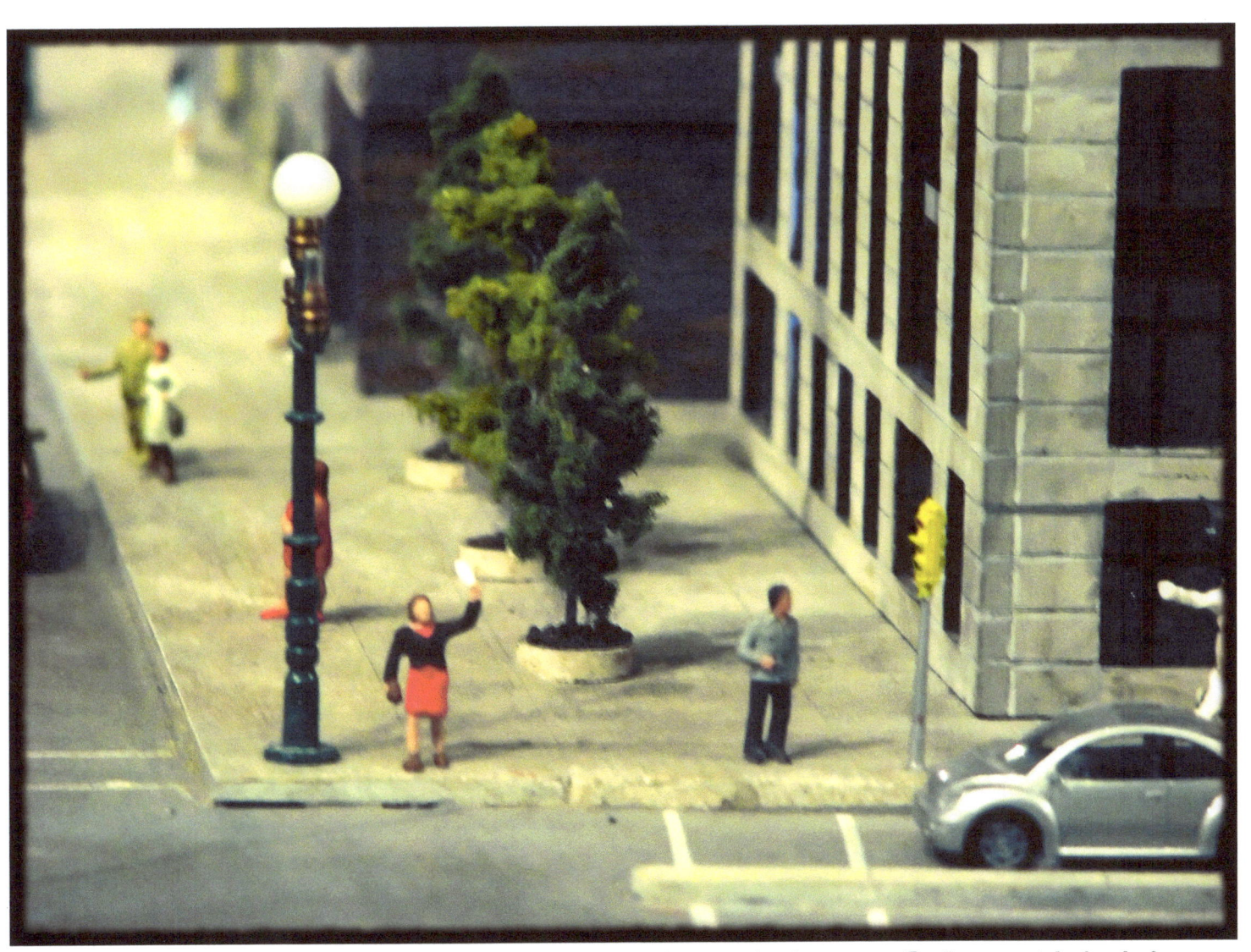
A correction introduced into false thinking.

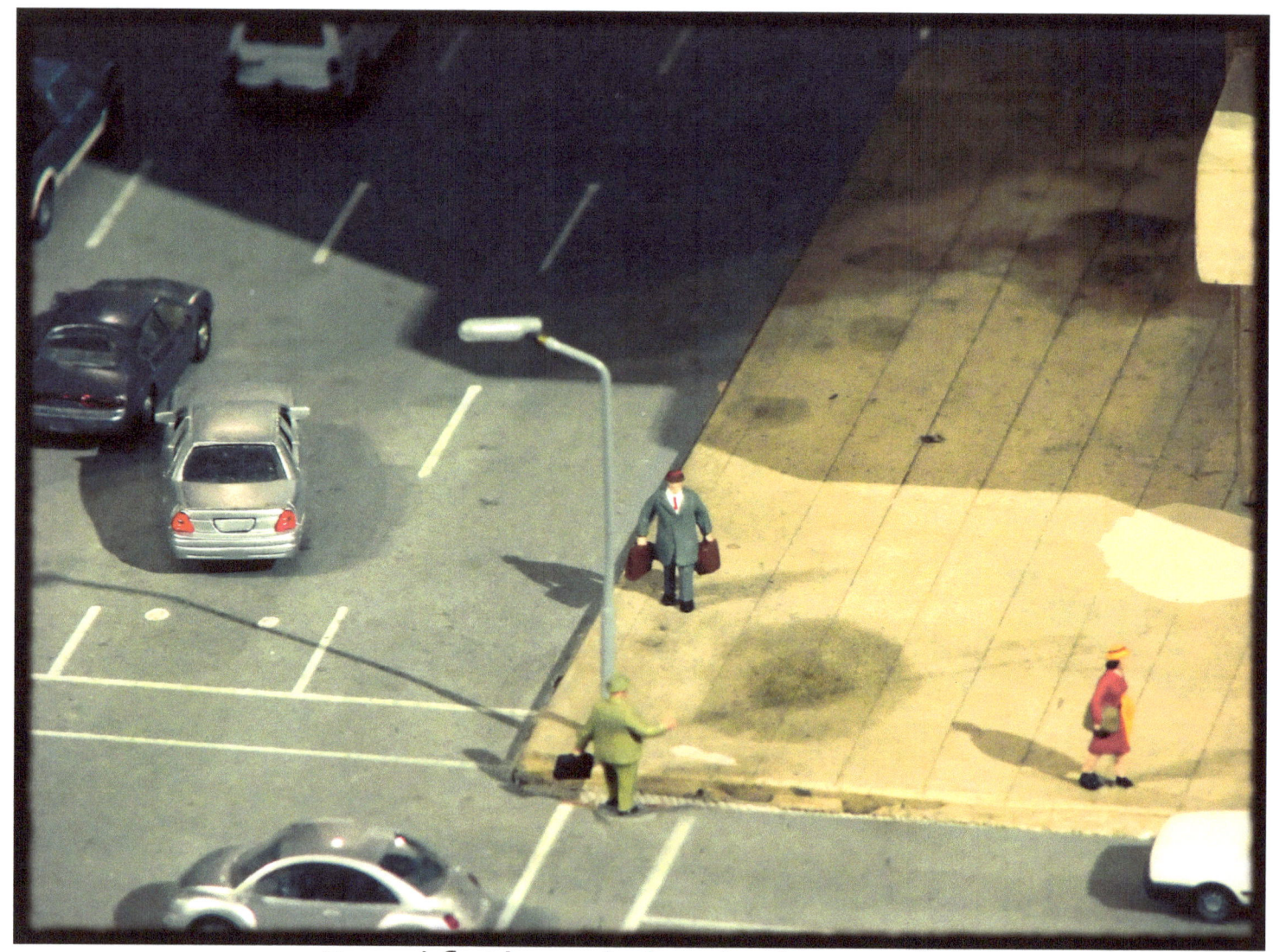
For if they joined she would lose her own identity.

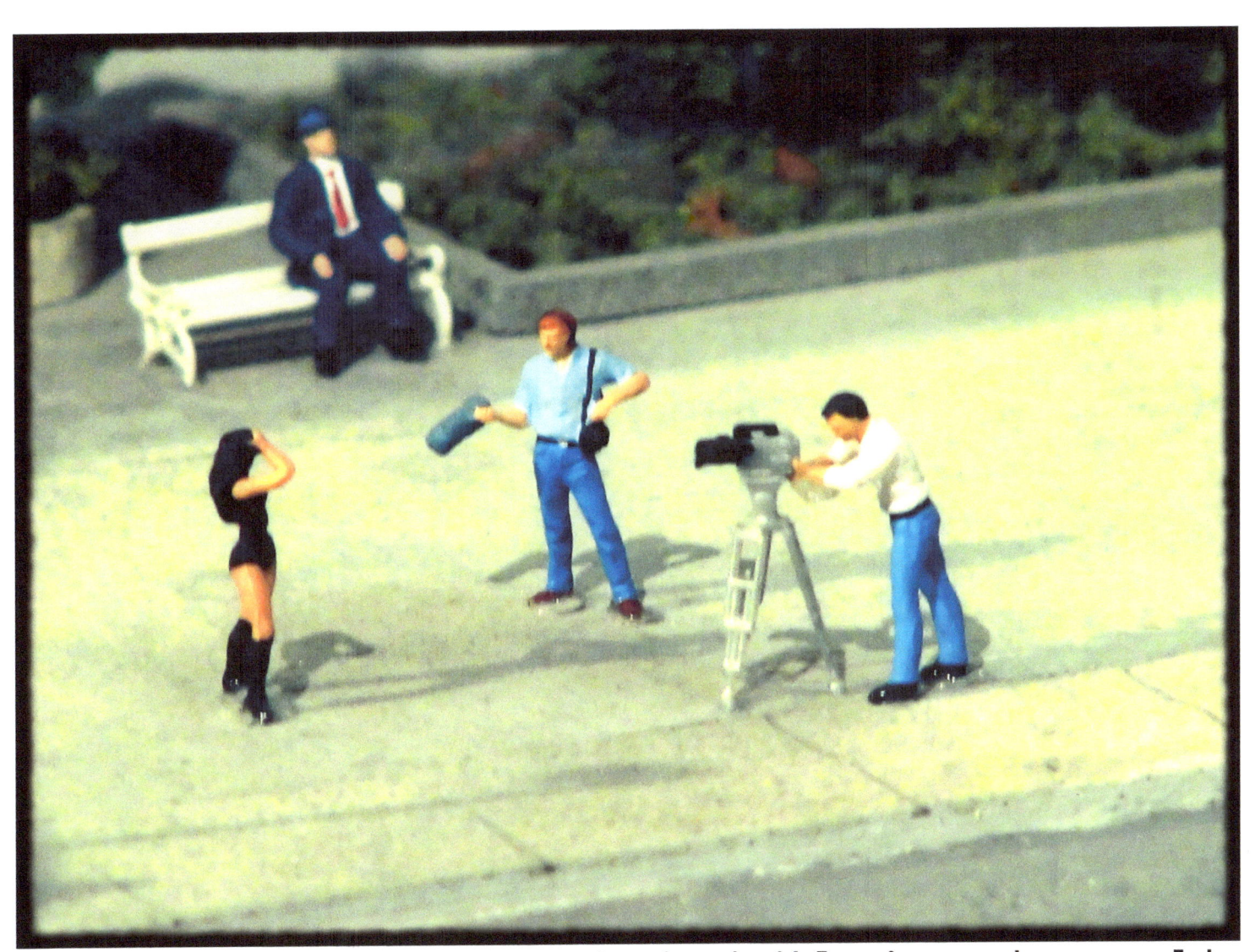

He is invisible in such a world.

www.ingramcontent.com/pod-product-compliance
Lightning Source LLC
Chambersburg PA
CBHW051101180526
45172CB00002B/729